ART LESSONS

ART LESSONS

Meditations on the Creative Life

DEBORAH J. HAYNES

Westview
PRESS
An Icon Edition

A Member of the Perseus Books Group

Published in 2003 in the United States of America by Westview Press, 5500 Central Avenue, Boulder, Colorado 80301–2877, and in the United Kingdom by Westview Press, 12 Hid's Copse Road, Cumnor Hill, Oxford OX2 9JJ.

Find us on the world wide web at www.westviewpress.com

Westview Press books are available at special discounts for bulk purchases in the United States by corporations, institutions, and other organizations. For more information, please contact the Special Markets Department at the Perseus Books Group, 11 Cambridge Center, Cambridge, MA 02142, or call (617) 252–5298, (800) 255–1514 or email j.mccrary@perseusbooks.com.

Library of Congress Cataloging-in-Publication Data
Haynes, Deborah J.
 Art lessons : meditations on the creative life / Deborah J. Haynes.
 p. cm.
 Includes bibliographical references and index.
 ISBN 0-8133-6598-8 (pbk. : alk. paper)
 1. Creation (Literary, artistic, etc.) 2. Art—Psychology I. Title.
N71.H335 2004
701'.15—dc21 2003012338

Typeset in 11-point Sabon by the Perseus Books Group

The paper used in this publication meets the requirements of the American National Standard for Permanence of Paper for Printed Library Materials Z39.48–1984.

10 9 8 7 6 5 4 3 2 1

For Mitchell

CONTENTS

PREFACE

These "art lessons" are about artistic formation and aspiration: about how you might become an artist, about how to sustain an artistic vocation, and about the creative life in general. Individual chapters are framed by and laced with personal stories that are relevant to the subject. In this sense the book resembles a memoir. It is episodic, divided into loosely connected chapters, each of which addresses a particular topic. The chapters do not focus on the acquisition of technical skills in particular media or on the art of particular artists. Using stories drawn from my life, each lesson instead seeks to speak to you, the reader, across personal differences and toward shared insights and experiences. The questions that grip me are big questions, philosophical questions, and the content of the book reflects this. I do not believe in universal truths, but I do believe that the truths of one life may illuminate another.

The book is structured around three major themes: forming a mind, disciplining the body, and cultivating spirit. Each chapter begins with short reflections about art, the future of art, and the future more generally. These statements

are prescriptive. Within the book as a whole, they constitute a manifesto, a public declaration of the values and ideas that have guided my work in the arts. And, like all manifestos, this is not a neutral tome, but a personal plea for an engaged artistic practice that is intellectually and conceptually grounded. I know that there are other views and values about art, about the artist, about the relationship between art and life. I do not wish to be either doctrinaire or dogmatic; these pages simply reflect what I believe.

The first part of the book, Forming a Mind, deals with the intellectual formation of the artist. How does one *become* an artist? How does the world of ideas intersect with and help to shape what you create? I have long questioned the notion that only certain people have artistic talents or gifts, but how and where does one locate the beginnings of an artistic temperament or proclivity? The process of maturing as an artist involves cultivating all of the spheres of life: the physical or somatic, the spiritual, the emotional, and, most of all, the intellectual.

The book's second section, Disciplining the Body, plays on the nuances of the word *discipline*. *To discipline* is a strong verb whose meaning moves in two distinct directions. On the one hand, *to discipline* means to train yourself, or to train others, in particular skills. The artist disciplines herself insofar as she simply goes to the studio every day and is present to see what emerges. He is disciplined in his wheel-throwing, as he practices centering the clay to make cylinder after cylinder. Such discipline is certainly aided by the teacher, but for the artist, developing self-discipline is crucial. On the other hand, *to discipline* also means to control, correct, or punish. All of us have experienced this kind of discipline, both in less obtrusive ways such as bells that ring in school buildings, and

through aggressive means such as corporal punishment. To say that the artist must discipline the body is clearly to focus on the first connotation. This section of *Art Lessons* examines the meaning of self-discipline for the artist, as well as ways in which creative practice and various technologies literally discipline and form the body.

The third part, Cultivating Spirit, addresses the inner psychological and spiritual life. With the phrase "cultivating spirit" I point you toward the most ethereal of realms, the inner worlds where we experience the deepest longings for union and for separation. Cultivating spirit has many aspects: thinking about religion, theology, and the sacred, including sacred space; considering the role of the teacher in your creative work; establishing a contemplative practice and exploring your art as spiritual practice; undertaking inner psychological work and facing adversity; and considering the relationship of your art to life itself.

Art Lessons speaks to three distinct audiences. First, parts of the book are elementary, dealing with fundamental issues that young and aspiring artists must consider. If you fit in this category, you might begin by reading the first few chapters in each part of the book. Other chapters will be of interest especially to older adults who have faced existential or spiritual transitions and crises. Such readers may be curious about or attracted to the arts at midlife or may want to revive earlier dreams, and for them, initially focusing on chapters according to curiosity might work well. A third audience consists of active professional artists and educators who are seeking inspiration for or renewal of their vision of the power and efficacy of art. The astute reader of whatever background will find a range of approaches, from the personal and anecdotal to the philosophical and scholarly. In

general, earlier chapters in each of the book's three parts deal with basic questions, and later chapters address more complex conceptual and philosophical issues.

Here, at the beginning, I want to say a bit more about my personal journey as an artist and writer, to ground the chapters that follow.

I began my adult life studying to become an artist. Then, as a result of my artistic practice, I became a philosopher of art. Or, as the process theologian John Cobb once said to me, perhaps I have become an artist-theologian. At this point in my life, I seek to integrate verbal and visual languages in my creative work. *Art Lessons* reflects this intention.

The roots of my formation as an artist and writer lie in childhood and adolescent experiences, both inside and outside of public school. Imagine a young girl singing "A, B, C, D, E, F, G, H, I, J, K, LMNOP . . ." I see this girl (myself), and I remember the pleasure of learning to read and to write my own words. When I was six I created my first book, "Debbies ABC Book," and wrote down all of the words I knew, from *apple* to *zipper*.

The urge to understand the world was one of my earliest aspirations. At age eight I wrote reports on clouds and butterflies. Each report combined drawing and writing, as I sought to describe the varieties of cloud forms and to represent the unusual beauty of monarchs, viceroys, and swallowtails. I was drawn to the most ephemeral of forms: clouds that changed shape as I watched, butterflies that seldom remained stationary for more than a moment. As a child, I wanted to read the physical world—to perceive it, to analyze and interpret what I saw, and ultimately to know and understand it. When I first saw a reproduction of Georgia O'Keeffe's *Sky Above Clouds IV*, painted in 1965, I was

fascinated, for the artist had captured the magic and grandeur of clouds. Later, when I saw the original painting at The Art Institute of Chicago, I was overwhelmed by the sheer magnitude of the space she had created.

In junior high school I wrote an essay about Charles Darwin's journey to South America, which he took between 1831 and 1836. Fascinated by the story of his explorations there, I included in the report a map I had drawn, which showed all of the places he stopped. I have always loved maps, and over the years I have created both actual and imaginary maps of places and journeys. Once, having gathered information for a journey to Alaska, I created an idea map of the state. Another time, I made a map of a series of dreams and literally stitched them onto a page. I have also collected time lines and cosmological diagrams during my adult life.

Reading about the origins and development of Darwin's theory of evolution gave me ample fuel for arguing about creation versus evolution with my classmates. When I first learned about the Gaia Hypothesis, I understood more fully that Darwin's theories were linear, based on a particular series of causes and effects among organisms in their environments. First developed in the late 1960s by scientists James Lovelock and Lynn Margulis, the Gaia Hypothesis describes our planet as a body rather than a place in space. All living beings on earth (the biota) are one integrated system, a total organism that includes the atmosphere and the surface of the planet. Even now, this conceptualization makes sense to me.

I do not know why I was so engaged by Darwin's travels and ideas during my early adolescence. Perhaps I was searching for insight into religion and into ideas about God. Or, perhaps I became interested in Darwin's visits to Latin

America because I had begun studying Spanish. My Spanish teacher was a strict disciplinarian and talked often about her own years in Castilla, Spain. I studied with her for three years, and then, when I began high school, I took up Russian. Three years of Russian study culminated in my first journey to Russia in 1967. Such experiences of learning the grammar, syntax, and vocabulary of others were utterly formative. Early in my life I realized that the world is full of the unknown and full of diverse people and cultures.

In college I had planned to continue in Russian and Slavic studies. But personal fateful events during the summer of 1967 prompted me to consider other options. I turned to the arts for solace and spent nearly twenty years getting to know my body and my inner self through artistic practice, yoga, and therapy. But these years were also marked by forays into philosophy, mythology, and psychology.

By a quirk of fate, in 1968 and 1969 I simultaneously took classes in Asian religions, Asian art, and hatha yoga. The synchronicity of this study had a powerful effect on my developing worldview in two ways. First, learning about the multiplicity of Asian philosophical and religious systems—about Buddhism, Taoism, Confucianism, and especially about Hindu gods and goddesses—dislodged any remaining belief that Jewish or Christian monotheism could adequately describe reality.

Second, I began to understand that art is a symbolic system for expressing complex cultural and personal ideas. I found the temples of India—from the Stupa at Sanchi to the Khajuraho complex—absolutely intriguing. Sung landscape painting and Zen gardens captivated my imagination. Along with this study, I explored all of the visual arts, from weaving and woodworking, to metalsmithing, painting, and sculpture.

But it was in the ceramics studio that I found my true home, and I spent my days and nights there.

Following both undergraduate and graduate degrees in ceramics, I held my first formal teaching position, where I loved teaching drawing and ceramics. My creative work became more exploratory, as I created tableaux, then installations and performances on a variety of themes.

However, in the mid–1980s, I decided to get a Ph.D. at Harvard University in religion and fine arts, and for the first time read widely in European and American philosophers, from Plato to Mary Daly. To say that this experience changed me is an understatement. My artistic productivity slowed, as I took up writing.

In retrospect, I can say that I focused on three major fields of inquiry, although it is difficult to order them sequentially. I wanted to understand the sacred, time, and the complex interrelationships of the self and, or in, community. Early in my life I had rejected traditional notions of God, but for years my creative work circled around notions of the sacred. What did I believe, I asked myself, if not in a Christian Father-Son-Holy Ghost? I made a concerted effort to articulate my view of the sacred and the divine, writing about mystery, creativity, and love. I analyzed the human cultural predicament, especially trying to understand the propensity for evil.

I wanted to comprehend time, but how can one really understand time? We treat calendar time as linear, yet body time is cyclical, as every woman knows. How did the cosmological time of myths fit in with the "great time" of historians, the geological time of scientists, and Christian eschatological time with its expectation of apocalyptic ending? Time is ultimately a conundrum. We experience it, we can track it. (A

few years ago, I began a series of large drawings titled "Marking Time." In one such drawing, I made marks for each day during a month. In another, I tracked each day with a drawing of a route I had walked. Yet another drawing in the series, completed over nine months, consisted of 252 individual sketches on a sheet of black paper that was twelve feet long and five feet tall.) Yet we cannot stop or change time's inexorable movement.

Throughout these years of study I continued to make art, primarily mixed-media drawings, paintings, and collages. At the time of receiving my Ph.D., this work culminated in an exhibition of forty works on paper.

Reflecting on this process, I am reminded of Henry David Thoreau's observation, in his essay titled "Walking," that one goes east to delve into the past, to understand tradition and history. I, too, have "gone east," both in the sense that I have traveled to the northeastern United States, and insofar as I have studied the religions and philosophies of the metaphorical "East." Thoreau saw the West as the future, full of human enterprise and adventure—a view that undoubtedly grew out of nineteenth-century ideologies about the United States. I continue to find in the West a sense of greater expansiveness that allows my vision and imagination to expand and stretch. Even now, I choose to live in the West, where the phenomenological world seems more pristine and wild.

In the years since completing my study, I have taught the history and theory of art in two departments where both art history and studio art are under one umbrella. I greatly value working in a context where artists, art historians, and theorists of art work together. Some years ago, I also undertook administrative work, as director of women's studies

and then as chair of a large art department. I spent years in the studio and then more years in the study. Now my creative life oscillates between these two spaces. This breadth of experience has given me tremendous insight into larger issues surrounding art education and the practices of art.

My experience has changed the way I view the historical art of world cultures and the way I think about the purposes of art. Art-making can be an activist or political act, in which the artist seeks to express what she or he sees and to effect change. Artists may create art for pleasure or entertainment, or for commercial gain or renown. There are many variants of such ideas. But this book reflects another view.

I believe that making and looking at art can be a form of contemplative practice, a space in our noisy and information-saturated lives for solitude, silence, and being in the present. Like prayer and meditation, art can become part of the foundation of who you are in the world, as intrinsic to your nature as breathing.

Art Lessons reflects such values and this interdisciplinary background and experience. There are no pictures or photographs in the book. Instead, you are invited to read with a pencil or pen or crayon in hand. Begin at the beginning, or begin where your curiosity draws you. The point is, simply, to begin.

FORMING A MIND

FORMING A MIND

1

THE ARTIST

To contribute toward the future, the artist must have a keen intellect, strong body, and compassionate spirit, as well as a developed inner vision and far-reaching outer sight. Keep your eye simultaneously on your next step and on the long horizon.

Cultivate stamina, for the artist's vocation is strenuous. It is not for everyone.

Artist is what I call a five-dollar word. Unlike the cheap ten-cent words such as *car* or *go*, *artist* is a big word. It can be full of pretension, or it can carry profound resonance. In an attempt to counter the pretenders, poet Carl Sandburg reputedly said that *artist* is a praise word, a designation that should only be applied by the community to a select few who embody certain accepted ideals. The national poet laureate, the Japanese potter identified as a national treasure: Such people are artists because they are recognized within their national communities. Only a few people can be true artists from this perspective.

Artist Joseph Beuys took an opposite approach in defining who could be an artist. Based on his lifetime of innovative

creative work, Beuys repeatedly said that everyone is an artist. Art is not the special province of the cultural elite, defined by an even more elect few, but it is an arena open to all. In today's world, Beuys's definition is much more compelling than Sandburg's. I believe, like Beuys, that artists are not born with special talents, though certainly some people have inherent gifts and proclivities that would seem to make their learning easier. Regardless of such gifts, however, I am convinced that artists are made primarily out of intention and imagination and creative action. So, if you want to be an artist, develop your intention first. Practice comes later.

To be an artist means *doing everything as well as you can*. I first learned this phrase as a young student, from art educator Tom Ballinger. He told us that, in practicing their arts, the Balinese would say, "We have no art; we do everything as best we can." This idea has long had veracity for me, and in our present cultural context, where the production of art for gain, fame, and consumption dominates, such an idea suggests another range of possibilities. All the acts of daily life are an arena for the aesthetic if we use this broad definition.

What do you feel called to become or to do in the world? Another way to ask this is, what is your *vocation*? This is not a frivolous question, for the conception we hold of our work profoundly affects what we create.

The word *vocation* has a complex history that reflects cultural changes over nearly 2,000 years, and consequently there has been considerable change in its meaning. The Latin *vocatio*, which means "a call," had a distinctly Christian tenor and referred to grace from God and to renunciation. For early Christians, it was blended with the idea of a special religious profession based on aptitude and right inten-

tion. The medieval mystic Meister Eckhart suggested, however, that this notion of a call from God should be independent of the monastic life and entrance into a religious order. He claimed that secular work, such as serving the needy, could be the arena for one's *vocatio*. In the sixteenth century, Martin Luther helped to effect a complete reversal of the term's original meaning when he asserted that only through work in the world could one realize a calling from God. Today the word *vocation* is virtually synonymous with job and labor for pay.

What if the artistic vocation were seen as a special profession based on right intention and right livelihood? What if artists were to reclaim some of the word's earlier resonances? What if an artist took her or his vocation as seriously as those in the twelfth century who devoted their lives to service of the poor? This sensibility would shift the attention and weight we give to our work. It would result in a new art.

Another way of conceptualizing the artist's work was suggested to me by Hannah Arendt's discussion of three different categories: labor, work, and action. All three might be understood as categories for describing particular kinds of art. Artists *labor,* and have labored in cyclical and repetitive processes to produce the artifacts needed to feed, shelter, and clothe both family and community. The gardener, the weaver, and the potter: These artists labor to create what we use every day. Artists *work,* and have worked to create material objects that we live with in our daily lives. The paintings or prints or sculptures that enhance our surroundings might be seen as the result of such work. *Action* refers to another level of activity, a new conceptualization of the art-making process. Art as action seeks to establish

new self-other relationships in this mysterious world that is the context for all of life. To understand art as a form of action means understanding that there is less concern with consumable products, though they may result from creative processes. The artist who engages in such creative action may or may not choose to make objects. But, to paraphrase Arendt, *the most important thing is to think what you are doing.*

To be an artist means integrating heart and hands, body and soul, mind and spirit. To be an artist means integrating one's art and one's life, bringing the arts into daily life and making life itself an arena for aesthetic and ethical acts.

2

AESTHETIC EDUCATION

Aesthetic education does not mean simply learning how to draw the figure or center clay or use the computer, although technical proficiency and skill are essential. In the twenty-first century, it means becoming a citizen of the world, knowledgeable about the past, analytical about the present, and reflective about the future.

The future is at risk. If you do not agree with this assessment, look around . . . at the air, water, human strife on every continent. Pay attention to what is happening in the world and to the planet. If the future is at risk, then your work matters.

Many paths lead toward the artist's vocation. You might attend art school or major in art at a university or college, and I will speak more about this option in the next chapter. You might apprentice yourself to an artist or artisan in order to learn your art or craft. You might teach yourself, as many so-called outsider artists have done. Howard Finster, for example, lived a long and creative life that is worth reviewing if you aspire to be a self-taught outsider artist. You might

have been drawing and making things since childhood, or you might be turning to the arts at midlife. Regardless of how you developed the urge to be an artist or how you decide to proceed, there are certain things you must know.

But before we get to this, I would like you to reflect on a question. Where did you get the idea that you wanted to be an artist? Before you read further, write a few pages about this. What influenced you to undertake study to become an artist, or to proceed on your own? In those early experiences lie clues to what you might do in the future, and I will have more to say about this later.

My aesthetic education began simultaneously in two spheres: the world of books and the world of nature. As a child, I loved to sit in my mother's library, located in an alcove of our family room. Rene Huyghe's *Art Treasures of the Louvre* was my favorite book, and my passion for images began during hours of studying the paintings. One image has remained more vivid in memory than others. In Henri Rousseau's *War*, an androgynous figure seems to be both sitting on and running beside a large black horse, which stretches across the canvas and over many naked dead bodies. The figure, now woman, now man, wields a sword and a torch. The sky is filled with clouds. A yellow horizon suggests both dawn and dusk, both the beginning and end of destruction. In the distance a town appears in silhouette. The picture is framed by two large gray-and-black trees, and the largest branch is broken, barely hanging from the tree. All remaining leaves are black; in fact, black is the predominant color. Interpreters of Rousseau's painting have described how total and final the carnage is. The figure, War incarnate, sows discord and death. But my child's eyes and imagination saw other possibilities: The horse might be Black Beauty, the girl

in white an angel or messenger of hope. Yes, the trees are burned, but as the miracle of life demonstrates, they will grow again. This is not only an image of death, but also of mystery and possibility.

Then, on other afternoons, I played in the woods behind our suburban house. *The creek, blackberries, nettle stings,* and *mud:* These words carry years of memory. Wandering in the trees and undergrowth, eating blackberries until my stomach hurt, getting stung by nettles and packing mud on my legs . . . exploring. Of course, the extent of exploration possible in a Seattle suburb was limited, but the experience filled me with both awe and love of the natural world. I spent time ambling. I climbed trees. I listened to the sounds of the creek. I would lie on the ground for hours, gazing at the ephemeral forms of clouds, finding within them a menagerie of meanings. Those same trees in which I perched would come to life: Trunks became torsos emerging from the earth; branches danced in the wind against the backdrop of blue sky. I tried to figure out the reasons for things. Once, when I was eight, I came inside and plopped down at the kitchen table. "Mommy, do you believe in God?" "Well, no, not exactly," she replied, "I don't believe in a Father God in the sky. I believe in *mother earth*—you know, the trees, grass, animals, the creek out back. That's where our support comes from. You know, like a mother, our earth."

These experiences, which occurred long before I made a commitment to study art, were formative. I learned as a child that sources for learning are everywhere, in the world around us, in people, in literature, music, and art. Over many years, books and nature have remained primary inspirations for me.

So, what are some of the crucial ingredients in aesthetic education? Here, I will mention only five.

1. Learn how to write. *Practice* writing. Writers from Augustine to Bertrand Russell, and Flannery O'Connor to Henry Miller have said that writing helps to produce the self. O'Connor and Miller claimed that they wrote to find out what they thought. Writing helps you to understand who you are and what you believe, and it will especially help you to articulate what you think. The visual arts provide the stage on which to act out this evolving understanding, but your art will be more articulate and you will be more successful if you can also write about it. I am not suggesting that you should necessarily publish your writing, or try to promote your own written interpretations of your work over those of viewers and critics. However, writing is a means of observing and knowing the world, and it is congenial with all forms of visual representation.

2. Whether you are a practicing or aspiring artist, develop a relationship to a sustaining tradition. But whose tradition? The nature of what constitutes tradition has changed rapidly in the contemporary world, as the history of world cultures has become available to us. We have opportunities to learn about diverse artistic traditions created throughout history, on every continent, by people of all backgrounds. Do not be narrow in seeking knowledge of the world, but expansive.

In contrast to modernist and avant-garde aesthetics that reject the past with its particular histories and traditions, I believe it is essential to consider how our multiple pasts might contribute to the formation of our collective present and future. What might an artist, interested in these cultural traditions, do with that knowledge? Appropriation and parody are two possible approaches to tradition. Appropriation is a powerful artistic strategy, especially when used with a

modicum of understanding of what one is appropriating. Parody, unlike satire or empty pastiche, involves a special form of dialogue with the past that understands its value, but also is critical and transgressive. Artists who learn about differing traditions are in a better position from which to create meaningful and rich artistic works of their own.

Once, in an art history seminar at Harvard University, Professor Oleg Grabar urged us to learn about monuments of world art. It did not matter if we were studying the early twentieth-century Russian avant-garde, ancient Mayan temple architecture, or Marquesan tapas. "Choose ten monuments from around the world," I remember him saying. "Learn everything there is to know about them." Over the subsequent years, I have chosen a few, and I am still learning. As a young student, I had studied about the Stupa at Sanchi, the Khajuraho temple complex, and the Ryoanji Zen temple. More recently, I have added the Russian *Spas nerukotvornyi* icon, the *Nike* of Samothrace, Remedios Varo's 1957 *Creation of the Birds*, the Tibetan *Wheel of Existence* thangka, and Kasimir Malevich's 1913 painting *Black Square* to my list. I am still learning about Navajo sand paintings, Aboriginal dreamtime paintings, and Ndebele painted houses. I use this knowledge in my teaching and in my creative work. These monuments serve as points of reference, touchstones for interpreting the present and for thinking about the power of art in the future.

For instance, the Buddhist Stupa at Sanchi was built between 100 B.C.E. and 100 C.E., and, like most ancient stupas, it is a shrine for the Buddha's and saints' relics. Massively decorated with secular people, the stupa cannot be entered, only circumambulated. By carrying out prayer rituals around the exterior of the structure, a Buddhist is blessed.

Through these rituals, a person reenacts the Buddha's birth into the world of form, his enlightenment and separation from the world, his first act of translating ineffable truths, and his attainment of Nirvana. Studying the Stupa at Sanchi was instrumental in my developing understanding of the ritual power of art.

Or, take the Hindu temple complex at Khajuraho. Constructed during the tenth and eleventh centuries C.E., the site originally contained eighty-five temples, of which twenty remain. They are dedicated to a variety of deities, including Vishnu and Shiva. The architecture combines verticality in mountainlike peaks with intimate interior spaces called womb chambers. Temple rituals by priests include bathing, purifying, opening the sanctuary where the image of the deity is housed and bathing it, and *darsan*, or "seeing the divine image." Private and congregational rituals are also possible, including circumambulation on the porches surrounding the temple. By gazing at the elaborate carved couples in ecstatic embrace, a person might meditate on *moksa,* or "liberation." The Khajuraho temples taught me that art is efficacious, that people's lives can be changed just by looking at art.

Or, consider Ryoanji, a Zen monastery in Kyoto, Japan. Ryoanji is the site of one of the most famous Zen gardens. It was probably designed by the fifteenth-century Zen priest Tessen Soki, who wrote that, in it, 30,000 miles seemed to be reduced to the distance of a single foot. About the size of a tennis court, the ground there is covered by carefully raked quartz sand. Fifteen stones are arranged in five groups, so that only fourteen can be seen from any one vantage point. In *The Japanese Garden* Teiji Itoh called Ryoanji "the ideal of a garden . . . the living blueprint of the perfect garden."

The idea that architectural structures and physical environments could describe and literally embody ritual space

and time helped to shape my evolving understanding of the function of the visual arts. I locate here the beginnings of my intellectual and aesthetic interest in creating contemplative space, an interest that has continued to the present.

Do not be afraid to give breadth to your study of cultural traditions. Depth will evolve in time.

3. Besides knowing something about cultural traditions, to become an artist you must also undertake training in order to know your materials and to attain technical skills. How can you make art—how can you do everything the best you can—if you do not know the materials and techniques with which you might work? Artists must therefore engage in rigorous technical training. Do you understand color? So, study the various systems of color in different cultures. Native American color aesthetics differ from the systems developed by Johannes Itten or Joseph Albers. Learn about the cultural significance of color. Learn how to mix paint to create the full color spectrum. Learn about the interaction of color and color relationships. Can you make a teapot that does not drip? Make one hundred teapots, until you can make one that is totally comfortable to use and that does not drip on the table when you pour the tea. To know a material, you must use it, again and again.

In urging you to attain technical proficiency and to gain familiarity with various materials, I do not mean to look back to some idealized past, when to be an artist meant that technical skills were highly developed. In my classroom teaching experience, many young artists are impatient; they do not wish to spend the time it takes to acquire technical proficiency. But here we could take a few lessons from Japanese master potters, or Renaissance painters, or from the Indian stone sculptors who carved Khajuraho temple. Self-discipline and patience go hand in hand with developing

one's skills. I am therefore in favor of rigorous technical training in the arts that might include the following, depending upon one's orientation and focus: drawing from life; learning how to move, speak, and sing, so that one's performances are not mundane; or acquiring a full range of computer-based skills.

4. Artists also have much to gain from becoming cognizant of, and entering into dialogue with, contemporary cultural theory. This is not a question of faddish sycophantism or tactical self-aggrandizement, but of understanding significant cultural issues such as pluralism, the role of others—especially women—and ecological and environmental concerns.

Theory derives from the Greek *theoria*, which had various meanings, including the sending of *theoroi* (state ambassadors sent to consult oracles), contemplation by the mind, and speculation. *Theoria* probably was derived from *thea*, "viewing," and *-oros*, "seeing," which suggests that perception and vision were significant. A theory allows us *to see* in new ways. The science of ecology, for instance, changed the way we understand the planet, for its basic principle is that we know organisms and the environment through study of their interrelationships. The Gaia Hypothesis changed the way we understand the planet even more profoundly. All things are connected. Feminism might be thought of as an ecological theory because of the kinds of connections it describes and prescribes. And so on.

I do not understand the point of view that loves ignorance, that thinks the creative process is most pure when carried out in total isolation from ideas and theories. Ignorance, they say, is bliss. But it is also unconscionable in the twenty-first century.

You really must, by the way, get a good dictionary that can teach you about what words mean and about their etymology. If you don't know a word, look it up!

5. As part of your aesthetic education, finally, I urge you to think about the question of audience. Reflect about the nature of the audience you wish to reach and the most effective strategy for reaching it. The last one hundred years have been marked by at least two major periods (the early avant-garde years and the present) when the gap between artists and the public has been very wide. If that gap, and the hostility that many members of society feel toward art, is ever to be bridged in even a modest way, then artists must think about who their *ideal* viewer would be and who their *actual* viewers are likely to be. Only when you consider others as an aspect of your own creative process will you be able to break free of stereotypes and pressures to conform within the art world. At least, if you choose to engage the art world in major international cities from New York to São Paolo, Prague, and Tokyo, you will know why this is your preferred audience. Then you can figure out how best to reach commercial galleries and art museums. Or, if you choose to give your creative work as a gift, then you will be aware of the nature of that choice as well.

This question of who your audience will be is intimately related to the way you understand yourself and your creative process. In some cultural traditions—for instance, for Russian icon writers and Tibetan thangka painters—the artist is urged to adopt an ideal based on anonymity. It is unlikely that many contemporary artists will adopt such an ideal widely, but it is certainly worth considering. Many artists today are devoted to art as a form of ego gratification, with the attendant financial and psychological rewards

that may accrue. Such values will probably remain the major motivating factor for many artists, as they are so central to what drives American life.

However, there are alternatives to a practice of art based on self-promotion and personal gain. For instance, we might consider the work of art as a gift rather than a commodity to be sold. In giving a gift the artist is not necessarily anonymous, but the presence of a second person, and a second consciousness, radically transforms the work of art into a rich aesthetic and moral act. Or, we might take the Balinese cultural value to heart and affirm that "we have no art; we do everything as best we can." Or, we might learn a similar idea from M. C. Richards, and treat the visual arts as an apprenticeship to life itself. Living and being then become one's art.

As Howard Singerman so eloquently articulated in his book, *Art Subjects, Making Artists in the American University*, contemporary art institutions such as the university have helped to shape a certain understanding of the disciplines of art, interpretations that are intertwined with professional and market pressures. But your aesthetic education can be shaped by other values as well, and your self-conception as an artist will evolve as you think about your audience.

Becoming an artist is not a mysterious process, though it is challenging. An aesthetic education requires intention, concentration, discipline, perseverance, and more than anything else, the will to learn.

3

SCHOOL

Use various kinds of institutions—from art schools
and colleges and universities, to libraries and muse-
ums—to extend your education. Take an active role in
shaping your own learning.

School. School days. Scolding teachers. Recess. Homework.
Agony. Or, possibly pleasure. The library, friends, caring
teachers. It is perhaps a truism that not all education happens
in school, but it is worth reflecting about your own goals re-
garding formal education. There are many options. High
school or a GED. University, public or private. Art school, in
the United States or abroad. A comprehensive liberal arts ed-
ucation or a more narrow focus on the arts themselves. Out-
side of school, apprenticeship to a master artisan or work in
a shop or artist's studio. Where do you want to be?

The story of my own relationship to school is instructive,
for it involved several kinds of institutions at different times
of my life, as well as self-directed study. Having come
through the trials of my teen years—having witnessed alco-
holism, divorce, attempted suicide, and near-fatal illness,
and having experienced pregnancy, relinquishment, parental

rejection, and a brief marriage and divorce—the university provided a haven and safe environment for me. I could not have survived without it. My studies focused in the arts, and I decided early to take all coursework on a pass-fail basis. I was less interested in being externally evaluated than in learning what I knew I needed to know. Although my bachelor of fine arts thesis in ceramics emphasized an inquiry about how to create green glazes with cobalt carbonate (which is usually blue), the thesis exhibition in 1972 also included a series of self-portraits, disturbing in their frankness and raw urgency.

Following this exhibition, I entered a one-year internship program and taught eighth grade in an inner-city school in Portland, Oregon. Most of the time I felt like a miserable failure, constantly railing against the very structures I was supposed to uphold as a teacher. After that year I knew I was not meant for the job, but I had gained a deep appreciation for the daily work that public school teachers must do.

With the encouragement of Bob James, then chair of the Department of Fine Arts at the University of Oregon in Eugene, I returned to graduate school, to a master's program in ceramics. I completed nearly two years of coursework, but in 1975, just one semester short of completing my degree, I decided to leave. "Walking out on the university" is how William Irwin Thompson named this act in a chapter of *Passages about Earth*. I had been in school or teaching steadily for over twenty years. Thompson had written of a different set of rhythms around which a person's life could be organized, a rhythm that included more time in the world, not always confined to chairs and classrooms where life was organized by bells and class periods.

Later, when I read nearly all the books of the French philosopher Michel Foucault, I experienced profound recognition of his "carceral continuum." Foucault claimed that all of society is structured around an interconnected set of institutions that function to normalize and control our behavior, hence the allusion to prisons in the word *carceral*. The family, school, factory, medical clinic, insane asylum, and prison: all occupy points along a social continuum. All are institutions that socialize. But they also exert their power, less benignly, in order to create "docile bodies," bodies trained to perform within society as they are told.

I left the Northwest and my long march through the carceral network, for the East and Thompson's Lindisfarne Association in Southampton, New York. In the mid–1970s Lindisfarne was a residential institute, an alternative to and refuge from academia—what philosopher Mary Daly has so sarcastically called "academentia." Although my undergraduate years had offered occasion for study of Asian cultures and philosophies, only in 1975 at Lindisfarne did I enter a highly charged intellectual environment for the first time. I had learned about Lindisfarne through reading Thompson's *At the Edge of History*, which was simultaneously a swan song for the twentieth century and a paean to the future.

We devoted ourselves to both serious study and spiritual practice. I sat zazen twice each day and practiced yoga. I learned about Sufism, Kabbala, and other esoteric traditions, and earned my way by teaching the children. Thompson gave inspired lectures on cultural history; Gregory Bateson talked about cybernetics and the structures of mind and consciousness; Nancy and John Todd described their New Alchemy Institute. While at Lindisfarne, I also participated in my first consciousness-raising group with other women

who lived there. My sustained analysis of patriarchy as the dominant cultural order didn't develop until later, but that group marked the beginning of my feminist awareness. Listening to stories of the other women was affirming and inspired determination to carry on.

I am blessed, and cursed, with a restless spirit; less than one year after joining the Lindisfarne Association, I left for England and points east. My goal then was to study yoga in India with B. K. S. Iyengar, but a letter from him suggested that I stay in England and work with senior teachers there. And so I did.

London was a wondrous city, so different from the provincial Pacific Northwest. There I began a new kind of self-directed education. I came to know the cultural life of the city very well, visiting museums, galleries, libraries, bookstores, and churches. Every day I wandered in new sections of the city, visited new sites. Although I had been to the great museums located in New York City, only during those months in London did I really become acquainted with the art museums of a major cultural center. William Blake's drawings and watercolors at the Tate Gallery, the Elgin Marbles and Lindisfarne Gospels at the British Museum and British Library, a large retrospective of Vincent van Gogh's paintings at the Hayward, innumerable contemporary exhibitions at galleries all over London: I took in as much as I could.

I traveled north to visit the holy island of Iona on the west coast of Scotland. Another time, I hiked from Berwick-on-Tweed to the site of the medieval Lindisfarne monastery, where the illuminated Lindisfarne Gospels had been scribed. I visited other holy sites such as Salisbury, Glastonbury, Avebury, and Stonehenge. Later, I made a pilgrimage to meet

aging potter Michael Cardew in Cornwall, about whom I had learned from my teacher David Stannard. We met in the town square in Bodmin, and he took me to see his studio and house. He showed me shelves containing extraordinary wares; Cardew was known for his exquisitely fashioned ceramic vessels. We talked about his lifetime commitment to clay and the value of the handmade.

During explorations around London, I discovered the Lucius Trust, which distributes the books of Alice Bailey and other esoterica. I worked for a short time in its shipping department. Lectures and concerts sponsored by the Trust offered opportunities to learn about artist Nicholas Roerich and to listen to the music of composer Alan Hovhaness. I had played his Sonata for Flute Solo as a teenager, but did not know the extent of his musical repertoire until hearing it in this context. During this period I read widely in mythology and world literature—from Milarepa to Rudolf Steiner—because I wanted to know how mystics and sages of the world's religious traditions expressed their experience of the divine.

Under the influence of viewing so much great art and reading voraciously, I began to draw and paint again. My drawings resembled tantric mandalas and yogic yantras. I claim no greatness for the art that emerged from this period of searching; in retrospect its primary value lies in the way it helped me formulate questions and articulate tentative answers.

Thoroughly immersed in yoga practice and Indian philosophies, I continued to investigate other religious and spiritual traditions—ancient, traditional, and New Age. I searched avidly in London galleries and museums for contemporary art born of impulses similar to my own. Mostly I was disappointed. In Oxford, however, I came across the work of

Richard Long, who documented his peripatetic wandering in texts and photographs. Like much of his subsequent work, Long's early *Roisin Dubh (A Slow Air): A Thousand Stones Moved One Step Forward Along a Seventy-Four Mile Walk in County Clare Ireland,* seemed an outward reflection of an inner journey. I have followed the development of his work ever since.

In January 1975 I had left graduate school in Oregon with no thought of returning. Fifteen months later, on the other side of the world, in the tiny town of Fionnphort where one catches the occasional small motorboat to Iona, I began composing a letter to Bob James, who was still serving as chair of the art department in Eugene. Bob had encouraged me to return to graduate study after my experience teaching public school and had been understanding when I left. Where, I asked him in that letter, was art that genuinely spoke to our spiritual condition? I wanted to try to answer that question through my creative work. I returned to school, completed the M.F.A. in 1977 with a series of drawings and written texts, and went on to teach at a community college and privately for nearly eight years.

Describing how decisions were made is easier in retrospect, and this is certainly true now, as I look back on the mid–1980s. I experienced profound clarity about my direction in the late fall of 1983, while attending an intensive yoga course at the B. K. S. Iyengar Institute in Pune, India. From the time of my undergraduate years, I had eschewed study of "my" cultural traditions. For instance, I avidly studied Asian art, but avoided taking courses in Western civilization or European art history. Suddenly, I wanted to know this cultural history. My family had emigrated from Europe between the seventeenth and nineteenth centuries.

What had happened there? What philosophical and religious traditions thrived on that soil? What forces shaped people's lives? To what historical traditions might my searching be connected?

Almost immediately upon returning from Pune, I packed for a trip to Washington, D.C., and New York City. In Washington, I attended the opening of an exhibition at the National Museum of American Art, where one of my drawings was in a juried show. Back home from India and from the exhibition at this museum, I applied immediately to graduate school. A few months later and nearly ten years after first moving to Lindisfarne in New York, I once again wound my way east to Harvard University. I spent seven glorious years there, devoted to learning all that I could about art history and the world's religious traditions.

Now I, too, work in a university. School, clearly, has played a formative role in my intellectual and artistic life. I recommend it. But, as in many spheres of life, you have to find your own way. Do not be afraid to leave school, but remember its utility.

4

WRITING

Write to find out what you think. Unless you know what you think, you will always be subject to the will of others, including the media that so pervasively shape contemporary culture.

Try to understand and state your motivations and reasons for believing and acting in particular ways. This is one reason to write. Draw to give your thinking visual form.

The reason for writing is simple. Through writing you will learn what you think and you will come to know yourself. When I write, I listen to inner voices. Sometimes they talk to each other, sometimes they just chatter. But sometimes, I am surprised as new perceptions lead to new thoughts, and suddenly I wonder where *that* amazing insight came from. Writing offers a special kind of access to the heart and mind.

I did not grow up writing, though I still remember the joy I felt at age eight, when I completed my first two reports on clouds and butterflies. Not until I was a student in ceramics did I begin to keep a journal, and this is a practice I recommend to you most highly.

At first, I just kept notes about glaze recipes and firing the kilns. Then I began to track my dreams and to use my journal to wrestle with both past and present experiences. By the time I returned to the University of Oregon from Britain to complete my master's degree, I was mainly interested in trying to redeem the artistic qualities of language, to infuse language with the color and mystery of other artistic forms. The "Logos" series, for example, consisted of mixed media drawings with text. Even then, I was wrestling with a dual identity as artist and writer. "I want to develop a coherent symbolic vocabulary," I wrote on one of the drawings, "an iconographic language. I seek to comprehend the universe, to represent meanings greater than verbal articulation can encompass. These symbols speak of mysteries: of the feminine, of birth and nourishment, of transformation."

Writing had become a way to create a matrix for understanding who I was and what I created. In another drawing from the "Logos" series, I examined writing itself: "In writing I analyze, which means to unloose or undo in Greek. Analysis involves breaking that which is complex into its simple elements, and it is generally deductive. Through writing I extend back into the past, I explore the present, and I reach out into the future. Writing is a way of asking WHY and HOW, and of seeing WHAT my experience is." Such texts were integrated with symbols drawn from dreams and reveries, imagery developed into an iconographic lexicon. I pushed at the boundaries of what constitutes art, asking questions about the purpose and function of the visual arts that presaged much of my later writing.

What *kind* of writing would I recommend? If you want to become an artist, your goal will not necessarily be to become an eloquent writer for a public audience. But as my

examples illustrate, writing is a powerful method for finding out what you think, which will serve you in writing everything from an artist statement to a grant and fellowship proposal.

Start by writing about yourself.

If this path seems of interest to you, I recommend a kind of writing that lies between memoir and autobiography: what Liz Stanley has called "auto/biography." With this term, Stanley raises many psychological, historical, and aesthetic issues that are pertinent to the kind of writing that I am suggesting. *Art Lessons*, for instance, might be thought of as just such an auto/biography, with lessons drawn from particular experiences.

On the one hand, a *memoir* is usually an account of formative events and their consequences, or it narrates a particular kind of story about your life. It does not purport to tell the entire story of what your life has been. On the other hand, *autobiography* reputedly tells the true chronological story of what has happened. This premise, however, has been radically questioned by postmodernists who claim that such metanarratives are no longer possible. Much of the time, in art as in life, we may attempt to tell the truth, but we still invent coherence. In telling your story, do not be surprised if you find yourself inventing pieces of the puzzle.

The term *auto/biography* brings attention to the complex interrelationships of selfhood, authorship, and representation. Using a genre that transgresses the boundaries between biography and autobiography and between fact and fiction, you can begin to understand that the self is not only individual and unique, but that it develops in ways that are closely articulated with the lives of others. Authorship and creativity, then, take on new meaning. Certainly it is usually a single

hand that marks and writes, but the self is so enmeshed with others' lives that meaning derives from this complex inter-textuality, the nexus of relationships that commingle during a lifetime. How could I narrate significant parts of my life, for instance, without talking about specific mentors, teachers, or members of my family? They inhabit my conscious life. Writing about them—representing them—is part of the effort to make the absent more present and the invisible visible.

Inevitably, an element of fiction enters this process because representation exists symbiotically with one's lived life. "We expect our and other people's lives to have troughs and peaks," Liz Stanley wrote, "to have 'meaning,' to have major and minor characters, heroes and villains, to be experienced as linear and progressive, and for chronology to provide the most important means of understanding them, all of which are characteristics of fiction." Fiction. Fact. Try to tell your story directly, with an ear and eye to the objective accuracy of the events you relate. But remember that objectivity is a myth, because experience is inherently subjective. My "fact" may be my sister's "fiction." This distinction between the perceived and the actual also applies to the ways in which time and memory figure in a life.

So, practically, how might you begin to write this "auto/biography"?

Write about your past, your dreams, your present experience. Describe key relationships, places, world events. Everything is suitable.

Your age doesn't matter, as we have all had formative experiences worthy of description. People write memoirs not because their lives are finalized, but because enough has happened to make it worthwhile to reflect about the process of

past evolution and future transformation. If you are interested in reading others' efforts, try books such as Mary Karr's *The Liar's Club*, Alix Kates Shulman's *A Good Enough Daughter*, Nuala O'Faolain's *Are You Somebody?*, Jan L. Waldron's *Giving Away Simone*, and Barbara Wilson's *Blue Windows*.

Develop narratives that are thematic rather than chronological and discontinuous rather than linear. Try writing about fire, or water, and describe particular experiences with the elements.

Reject what might be called the "spotlight approach" that focuses on a single unique subject (yourself). Turn instead to questions of context and social location, to your position within social networks, including your family, and institutions such as your school or workplace. What is happening in the wider world right now? How do these events affect you?

Recognize the contingency of facts and arguments, a natural result of acknowledging your unique standpoint in the world. I, as writer, and you, as reader, each occupy a unique time-space nexus. This particularity thoroughly influences how we see and act. When you write, recognize that no one else will see the world quite like you do. To develop an understanding of this, you might write a description of an event from another person's point of view.

Depart from realist principles and practices by disrupting chronology, by disputing fixed notions of sex and gender as well as of reality itself, and possibly by confounding the certainties of the reader. All of these help to show that life is not that simple. What if you wrote about your life from the perspective of the opposite sex? How might that change your sense of things?

As you take on such writing exercises, you will see that writing raises complex psychological questions concerning the

nature of the self. Some scholars have suggested that women and men write differently. Consider the following three points.

According to this perspective, men tend to write linear, chronological, coherent narratives, while women often produce discontinuous, digressive, and fragmented narratives. These are, of course, value-laden words for describing distinct styles of writing, where men produce the standard model and women deviate.

Men tend to be concerned with public achievement; women with personal and intimate life. I write of both the personal and public spheres, wrestling with my ambition and desire for public recognition. As a woman, I have struggled to achieve in a public world that is already marginalized within mainstream U.S. culture—the visual arts. But this sphere is still dominated by men; one only need look at the latest statistics circulated by the Guerilla Girls performance group for corroboration.

Men tend to focus on the self in isolation; women on the self in relation to others. I consider myself to be defined through relationships to places, events, and persons. Relationships are, in fact, a major focus here: the ways in which new technologies cannot be separated from issues concerning nature, place, and landscape; my engagement with Russian culture, art, and philosophy; my long involvement with yoga, particular teachers, and travel, especially to Greece and India; and encounters with suffering and death.

Ask yourself how such ideas might apply to your own writing. Do you write like a woman? If so, can you write like a man? Do you write like a man? If so, can you write like a woman? The point here is just to be aware of the ways in which gender and social conditioning influence writing. Ask yourself what kind of writing best serves your needs.

As a writer, you will inevitably engage in multiple interpretive acts. Similes and metaphors, for example, (in)form the essential quality of any narrative and can be used to make your writing more vivid. Perhaps "the world is a forest"—life a process of making our way through that forest, and we the sojourners, sometimes traveling on already existing paths, sometimes creating our own. We come to a clearing, stop and rest, cultivate the land, build a structure in which to live. Sometimes wandering in the forest leads one back to a familiar crossroad. Often one encounters the unknown, the unexpected. Dangers lurk, especially if one does not know basic survival techniques. Such a benign simile results in a completely different narrative than another image, such as "the world is a battleground"—a site where we risk our lives repeatedly, conquer enemies and demons, and wrestle with angels. For me, the world is more like a forest, full of risk, danger, and potentiality—a place where struggle is necessary, but armed combat is not. Experiment with such similes and metaphors in your own writing.

Each descriptive phrase will carry specific memories and images that form smaller narratives within the overall narrative of a life. But all efforts to define yourself through memories and narratives have boundaries and limits. As Mikhail Bakhtin has observed, boundaries run through the cultural sphere in all directions. One is always encountering limits—the limits of one's ability to understand or interpret, the limits of knowing itself. More than anything else, I urge you to write in a style that is intertextual and polyphonic. Let many voices speak. Concrete events, persons, and conversations of everyday life will form the foundation of your reflection, but your inherent curiosity may take you into the world of ideas.

And what of historical sources? You might try writing with the aid of photographs and other images. All such sources offer perspectives on given historical moments, but none can be relied upon to give a complete picture. Even the act of rereading what you have written and of looking at old photographs is closely tied to memory.

Finally, all experience is perspectival and subjective. Your experience depends upon your standpoint. Memory helps each of us to shape our orientation toward and vision of life. Without memory we live in an eternal present, which might sound obvious, but it can also be disorienting. Memory has its limits because the self you imagine and describe is always partial. You may link persons and events to particular feelings in memory that were not connected in the past as it originally happened. Therefore even historical writers often use the devices of fiction in reconstructing the "actual" past. In this way history begins to blend with fiction and new aesthetic issues are raised.

Writing your auto/biography will not refer to your life in ways that you assume it should. Because memory is selective, because most events and persons in your life are probably forgotten or half-submerged in memory, the process of piecing together memories of the past to form a more or less coherent whole is highly selective.

Writing about yourself is a way to begin the process of becoming comfortable with language, setting pen to paper or hands to keyboard. The possibilities of what Annie Dillard calls "the writing life" are immense, once you have begun.

5

READING

Read to find out about the worlds of others. Self-satisfied narcissism has no place in the life of the serious artist today.

In order to write well, you must read. Sometimes I think that reading has become an esoteric activity, undertaken by only a few who grew up before the age of the ubiquitous screen. So I say to you, read indiscriminately, read with curiosity, and read voraciously. I am a firm believer in the idea that you should "follow your nose"; that is, let your curiosity guide your explorations.

Reading is not the same as online surfing and skimming through websites and email. Reading is one method for learning to follow a long thought, to follow the stream of another's consciousness until we understand what that person perceives and thinks.

I am reminded of a story told about Karl Marx that illustrates this point. When he began reading the German idealist philosopher G. W. F. Hegel, Marx would copy out a paragraph from Hegel's text, then write his own comments beneath it. I have always found this to be an enormously help-

ful way to begin writing. Try the exercise that Marx found so rewarding. Select a short text that is difficult, but compelling to you. Copy it onto a page. Then write your own reflections about what you have just copied.

Reading is not the sole prerequisite for writing, but it is a powerful impetus, for reading introduces us to the world(s) of others. Without exaggeration, I can say that I have always loved reading. As I child I read voraciously, picking up whatever was around, reading even at night when I was supposed to be sleeping. As an adolescent, I spent many Saturdays in the local library, reading books that I found there on philosophy, poetry, and psychology. At other times I sat by the bookshelves in my mother's library, with art books and tomes by existentialist philosophers such as Jean-Paul Sartre and Albert Camus. I read periodicals at school on world affairs and participated in debate class during high school. The proliferation of nuclear weapons and disarmament were timely topics, and my political view of the world was formed as I learned about war and weapons of mass destruction.

When I was a high school and college student in the 1960s and 1970s, the civil rights movement was in full swing. As a child in white suburbia, insulated from the experiences of people of color, I gained access to their world through reading. I read *Black Like Me*, the *Autobiography of Malcolm X*, the poetry of Langston Hughes, and novelists Richard Wright and James Baldwin. Like many others, it took years before I would read Toni Cade Bombara, Zora Neale Hurston, Paule Marshall, Toni Morrison, Alice Walker, and Margaret Walker, women who have since been recognized for their unique insights into the realities of African-American experience and racism.

Of all the literature I read in late adolescence, James Baldwin's *Nobody Knows My Name* probably had the greatest influence. The book was written "in various places and in many states of mind" during the 1950s. Baldwin was writing about his invisibility as a "Negro" writer who was just ending a six-year self-imposed exile in Europe. His essays covered many topics, including a long eulogy for Richard Wright and an essay on Norman Mailer. But more than anything else, Baldwin wrote about racism, what he called "the question of color," and "graver questions of self." This early introduction to writing as a way to explore identity along all of its vectors—ethnicity, gender, age, ability, sexuality, as well as cultural and social issues—was absolutely formative.

"It doesn't matter what you read," I once told a class of eighth-graders. "It only matters that you make space and time to encounter the world through others' eyes and voices." It does not matter what you read. Newspapers and magazines, comic books and zines, novels and poetry, essays and biographies: learn about the world through reading. Keep a reading journal like Marx did. This will greatly enhance your writing and your creativity in general.

You might take a look at books such as M. C. Richards's *Centering in Pottery, Poetry, and the Person* and *The Crossing Point*. Notice how she integrates personal stories with didactic content. Or, read Robert Henri's *The Art Spirit*, which was compiled by one of his students from his lectures and talks. It contains sound advice about becoming an artist and about the work that other artists have undertaken.

As a postscript, a few further words about the relationship of writing and reading. In contemporary American society, we often hear about how students must learn the basics— "reading, writing, and arithmetic"—with the assumption that

reading comes first. Somehow, we are led to think that reading is a prerequisite for all other intellectual endeavors. I disagree with this assumption. Before they could read, human beings made marks. The artist David Smith once said that drawing, as a form of mark-making, came first in human experience, even before song. Writing is indeed a form of mark-making; reading can teach us to create more complex marks. Probably it is a fallacy to try to assert that one activity is preliminary to the other, but I know, through my own experience and through my teaching, that writing and reading nurture each other.

6

TRADITION AND HISTORY

Knowing about the past will aid you in dealing with the present. Do not be afraid of tradition or of traditions. You cannot create the new in a vacuum. Remember the old adage that those who do not know the past are condemned to repeat it.

Study the arts of various cultures across time. Find out what impelled people to create in other times and places. Find out about their technologies and about the products of their endeavors.

How do you learn cultural history? And more to the point, whose history should you learn? There is no simple answer to this question. You can learn social, political, and economic history through art and the artifacts of human invention. You can also focus on traditions close to home and learn their rich histories. You can learn where your own people came from, the lineage of cultural traditions of which you are a part. You can, of course, choose to be myopic and never learn about others. But I say to you, study the art of the world, of traditions and cultures across human history.

Earlier I acknowledged how formative Asian art was for me, for through my study of it I began to understand art as a symbolic system for expressing both cultural and personal values and worldviews. During my adult life, I have also spent many years learning about the history of art, about theories of the image and icon, and about controversies concerning the use of images. I have read books, studied pictures, met people, gone to museums, and I have traveled. In particular, travel to Greece and to Russia since 1967 has helped to shape my understanding of cultural traditions and history itself. Being in cities such as Lucknow, India; Boston, Massachusetts; and Mexico City for differing periods of time has served as the catalyst for learning. I will have more to say later about the personal dimensions of travel, about people and how they live, and about the impact of travel on one's understanding of the world. Here, I want to take you on a couple of journeys that broadened my understanding of tradition and history.

Approaching the northern Aegean island of Samothrace by sea, one sees a looming conelike shape that reveals its rock masses and ridges as the ship sails into the island's only harbor. The mountain is called Phengari, Mount of the Moon. The sanctuary on the north coast, where the famous *Nike* was found in 1863, is bordered by two long ridges that rise steeply to culminate in tumultuous *petra*, or "rock." Depending upon one's vantage point, the 5,000-foot rock mountain appears as either one or two peaks.

One morning, I was given directions for walking the few miles to Paleopolis, site of the ancient mysteries and ongoing excavations. Although the date of the earliest uses of the

sanctuary remains uncertain, ceramic inscriptions have been dated to the fifth century B.C.E. During the classical and Hellenistic periods, the Samothracian sanctuary and its mysteries were widely known and attracted numerous participants and visitors. In 84 B.C.E. the site was badly looted by pirates, and a major catastrophe, probably an earthquake, caused extensive damage. But the sanctuary buildings were remodeled and the site flourished until the late fourth century C.E., when political and religious pressures forced it to close. Careful excavation and study of the site have been underway since 1938.

I stopped at the Hotel Zenia in Paleopolis to leave a note for James R. McCredie, the archaeologist who was then leading the excavations. He was to arrive later that week, and I hoped to talk with him. Finally, thinking that I was following the trail to the site, I began walking. To my surprise this "trail" ended in scrubby brush, and then I followed a small herd of goats. A startled hawk flew squawking into the air. I pressed through brambles, wondering if this was how seekers in the fifth century B.C.E. had first approached the sacred site. Reaching a clearing, I caught sight of the Hieron, one of the largest remaining structures, and realized that I was not on the trail at all. At last I climbed over a fence that encircled the current excavations. Inside, it was quiet except for cicadas, bees, and flies. The sky was gray, the sun obscured by clouds. I sat for a long time beside the Sacred Rock, a large outcropping of blue green porphyry, in silent contemplation, experiencing the joy that accompanies the simple presence of Being.

Archaeologists present a complicated picture of what occurred at the site. In the earliest mysteries a plurality of deities were grouped around a central figure, the Great Mother, whose antecedents in Greek and Phrygian mythol-

ogy were Rhea, Hecate, Aphrodite, and Cybele. Later, after the Hellenization of Samothrace, the familiar Demeter-Persephone-Hades triad can be identified. According to Karl and Phyllis Lehmann, the cult included many elements characteristic of other mystery religions: sacrifice of animals, libations, prayers, vows, processions and ritual dramas, votive gifts, and initiation rituals.

Hans Gsängert, a student of Rudolf Steiner, has suggested that the Samothracian cult had both exoteric and esoteric aspects. The exoteric dimension was related to myths about and rituals for the Great Goddess and the Kabeiroi, her attendants. The esoteric dimension was more concerned with the correlation of spiritual and physical processes in human development.

According to Gsängert, Steiner was convinced that the mysteries of Samothrace were the source of two important ideas within Western religious traditions: that the essence of human being is immortal and that Nature and Spirit are manifestations of the same substance or process. Thus, Gsängert claimed that the natural and moral worlds were unified in the Samothracian mysteries. Not only was Nature seen as an embodiment of Spirit, and hence revered in all of its multiplicity, but humans were also morally linked in this nexus. We certainly still need such an understanding of the world and earth as sacred, as well as attitudes of accountability and responsibility that were cultivated in the Samothracian mysteries.

Found lying in a ditch at the site and missing her head and arms, the winged *Nike* of Samothrace is now considered one of the most important artifacts of ancient art history. It is certainly one of the most famous statues in the Louvre Museum in Paris. Made of marble from the island of Paros,

the *Nike* is approximately eight feet tall, with large wings that are open behind her. Originally seen as if the figure were alighting on the prow of a large ship, the statue was set in a pool of water and overlooked the site. With her right leg forward, the goddess of victory wears a long gown that is pressed against her body, as if in a strong wind. Visible from a great distance, she stood in the portico of the elevated sanctuary of the Great Gods. There are still changing interpretations of both the actual date of its carving and installation and the purpose of the statue. Dates range from between the late fourth to the late first century B.C.E. It is not known whether the *Nike* commemorated a particular victory, symbolized the modest naval power of the island, or served as a generic symbol of power.

If I had never traveled to Samothrace, I still would have been interested in the *Nike,* and I might have inquired about where it was found. I even date my fascination with writing words in stone from my visit to the sanctuary and learning that the ancient stone remnants have provided vital information about the past. My urge to find out more about Greek history and art was intensified by my journey there. The same has been true about Russia.

My earliest awareness of Russia was of a country hovering dangerously where the sun set, poised behind Japan. I realize, of course, that such spatial metaphors are geographically and topographically inaccurate, but they formed my first images of the country. Even the name "Russia" is no longer technically correct to describe this vast land of independent states. Still, the name retains a certain descriptive power related to the country's long history.

As an adolescent in the 1960s, I studied Russian and imagined working on the world stage. I wanted to learn about this radically other place. I never believed that the people of Russia were enemies. Looking west across Puget Sound, the Olympic Peninsula, and the Pacific Ocean toward the Russian Far East, I was immensely curious about Vladivostok, then a closed port. Since the early 1990s, working on exchange activities with artists from Vladivostok and attending international conferences in Moscow and St. Petersburg, I have had the opportunity to get to know what life is like there now. Such experiences have provided the impetus for learning more about Russian traditions and history.

The former Soviet Union is big and full of the unknown. In youth I knew that it was full of missiles pointed at us. Now it is full of nuclear materials that are sold surreptitiously to the highest bidder. Now it is home to a people angry and unsettled, and a people trying to create the future under duress and in situations of great privation. Now it is home to a class of "new Russians," aggressive capitalists who flaunt their newfound riches. Now it is home to visual artists reestablishing themselves on the world stage.

Simultaneous similarities and differences characterize Russia and the United States, as Yale Richmond and others have described. Both are countries of tremendous ethnic diversity; both have expanded across continents, destroyed and exploited wilderness, displaced indigenous peoples, and developed as great powers. Both are, or at least were, nuclear powers and must cope with the environmental consequences of nuclear energy and weapons development. Both peoples are energetic, inventive. But the differences are also great. At least during most of the twentieth century, the Soviet Union functioned through a centralized government in which power

usually flowed down, whereas the United States—in theory if not always in practice—developed a model of representative government in which power is supposed to flow from the people. In reality, the power of the nation-state as a separate entity is waning and is being replaced by a new multinational corporate world order. Now, venture capitalists, technologically literate writers, and artists in the United States and Russia probably have more in common with one another than with many others within their own national cultures.

Still, traditional Russian communal values contrast with the American individualistic ethos. Our economic systems differ; our historical experiences are radically different. The relative youth of the United States, combined with the fact that most of its wars have been fought elsewhere, contrasts markedly with Russia's ancient history and the suffering that people have experienced since the twelfth-century Mongol invasions. Who can measure the overall impact of such differences and similarities?

Before I knew all of this, a 1967 visit to the Hermitage Museum in Leningrad (now known again as St. Petersburg) opened new horizons for me. This was my first experience of a major international museum, as I had only been to the original Seattle Art Museum in Volunteer Park. I still remember the vivid sense of wonder as we wandered through the halls of Greek vases, Roman statues, medieval and Renaissance sculpture. Coming unexpectedly upon Michelangelo's *Crouching Boy*, I sneaked a quick touch, against all the rules, but the marble sculpture was already brown from the skin oils of countless others before me. Then, entering the modern galleries, I saw Rodin's *Age of Bronze*, majestic in a quiet way, sensuous, palpably real. Only much later would I begin to analyze the heroic male form in terms linked to the assertion of

power and privilege, and learn about the sculptor's atelier where young artists such as Camille Claudel helped to carve the marble works attributed to Rodin.

Turning to descend the stairs, I was greeted by Matisse's huge painting *The Dance,* created in 1909 and 1910. What spectacular color and energy in his circling dancers! I was utterly captivated, and in those moments in the Hermitage my fate was inexorably changed. Unexpectedly, I felt the calling of the arts, the birth of a desire to be an artist rather than a translator. Of course, the languages of art *are* translations in a sense, modes of interpreting perception, cognition, and affective experience. My youthful aspiration of doing Russian language translation, even for noble international causes, paled by comparison.

I have offered these two specific examples—of how learning about two places led me into cultural tradition, mythology, social history, and art history—in order to demonstrate that such knowledge need not be centered in books. Books and other media are, of course, excellent resources for learning. But, for me the experience of being in places has also provided the impetus for learning about tradition and history. I urge you to use your experiences in the world to do the same.

7

PHILOSOPHY

The disciplines of philosophy can help you to articulate your worldview and ethos, your beliefs and values. Without a clear sense of what you believe, you will be controlled by the forces that define consumer culture. Philosophy will help you answer questions such as, why is there something and not nothing? Why am I here? What is the meaning of my life? What am I destined to be and to do?

For as long as I can remember, I have asked questions about things in the world, about events and people. I think through questioning, through inquiry. For me this is not solely a function of the wish to know, but it has become a dialogical style. I live-myself-into the present and future through questions. This love of exercising curiosity and intelligence is philosophy.

The word philosophy is usually translated as "love of wisdom," but I prefer broader definitions. In *Some Problems in Philosophy*, American philosopher William James described philosophy as "a collective name for questions which have not been answered to the satisfaction of all that have asked them." Anthony Quinton, former president of

Trinity College, Oxford, said that the most direct definition of philosophy is "thought about thought."

From such an all-inclusive perspective, any time we exercise our curiosity, ask questions, and use the intellect to wrestle with possible answers, we are engaging in philosophical acts. Of course, the term is also used to cover a wide variety of activities and domains of knowledge, both technical and general. In later chapters I will have more to say about three specific types of philosophical inquiry: epistemology, ontology, and axiology.

My artistic practice has been shaped by living-myself-into a range of philosophical questions. I learned this strange locution, "living-myself-into," from Russian moral philosopher Mikhail Bakhtin. In his essay "Toward a Philosophy of the Act," written in the 1920s, he described aesthetic vision as composed of several steps, one of which is *vzhivanie,* "living-into." He coined this term, which has no direct English equivalent, to illustrate how we project ourselves into a moment or situation. We experience and empathize; we live-ourselves-into another's ideas, feelings, or experiences before returning to our own positions.

I ask, what *is* ethics? What *is* aesthetics? Both ethics and aesthetics are broad philosophical categories that encompass huge arenas of human experience and aspiration. In the simplest terms, an ethical system articulates values and rules we hold around "the good" and "the right" in our thought and action in the world and toward all living beings. Aesthetic systems purport to tell us about beauty, ugliness, and what we might call fittingness—how well and appropriately things fit together.

I presently conceptualize my creative work as an attempt to practice "ethical aesthetics," integrating ethical and aesthetic

concerns through art. Dealing with moral, religious, and meta-physical ideas; linking them to inherited knowledge and wisdom; reflecting about one's responsibility for perpetuating values; and especially, translating knowledge and values into practice: These are at least part of what it means to be an artist who practices ethical aesthetics.

In the Enlightenment philosophy of Immanuel Kant, ethics, aesthetics, and science were understood as the three primary arenas of human concern. I have already offered definitions of ethics and aesthetics, but science may be defined as the arena of human cognition, reason, and knowledge that enables us to know the world. In Kant's view, ethics, aesthetics, and science each occupied its own autonomous sphere and was seen as separate and equal. Kant himself wrote separate treatises, his three *Critiques*, on each one. My work has been a sustained effort to reconnect the ethical and aesthetic spheres.

I have been greatly helped in this process by sustained reading in the histories of religion and philosophy. I say "reading in," because I do not claim extraordinary breadth or depth. My curiosity led me to study Russian, French, and German in order to try to read Mikhail Bakhtin, Hélène Cixous, and Hermann Cohen in their original languages. I read Kant, Hegel, Ludwig Feuerbach, and Marx carefully. I studied twentieth-century philosophers and worked through all the writings of Bakhtin and Michel Foucault. I read widely in women's history, feminist theories, theologies, and thealogies.

Each of these philosophers and philosophies has served for me as a foil. In metalwork or jewelry, a foil is a thin layer of bright metal that is placed under a gemstone to give it added brilliance. A foil is not an adversary; it helps to con-

trast the uniqueness and potential problems of one object, event, or person in relation to another.

I would identify the German idealist philosopher G. W. F. Hegel (1770–1831) as a primary example of such a foil in my intellectual development. For me, Hegel's philosophy provided a rationale and justification for artistic practice.

For many years, I felt a dim kinship with Hegel, predicated on my vague knowledge of his interpretations of time and spirit, which he called "Absolute Spirit" or simply "Spirit." Long before I read Hegel, I had encountered his ideas in Mircea Eliade's work, and I was familiar with the writings of Pierre Teilhard de Chardin, Sri Aurobindo, Rudolf Steiner, and Jungians such as Erich Neumann. These thinkers posited an evolutionary, teleological understanding of the development of consciousness in human history that seemed persuasive to me. Reading Hegel was a gratifying process of locating an urtext on which these others were based.

But more than this, Hegel claimed that art, along with religion and philosophy, was a primary means through which Spirit is manifested. I knew from my own experience how powerful artistic creativity was, but what an idea! I was hooked, and wanted to understand more. Reading Hegel's *Phenomenology of Spirit, Introductory Lectures on Aesthetics,* and his *Lectures on the Philosophy of Religion* helped me understand how some of our cultural ideas about art, religion, the sacred, time, and self-other relationships were established historically. His method of thought was, and remains, compelling to me.

Hegel's philosophical method was founded on the need to be self-reflective and self-critical. He insisted that there can be no knowledge that is not mediated, though this mediation takes many forms. He examined how experience is

shaped by and helps shape our conceptual frameworks, and how language itself shapes reality. He asserted that we must become clear about our own presuppositions by exploring them. We may fault Hegel for insufficient self-consciousness, but he pointed a way.

Hegel was a dialectical thinker because he tried to "think-in-relation." He sought to take account of history, process, and interrelationships, always searching for the connectedness of events, things, and persons to one another through relations of opposition and interaction. For instance, he acknowledged that both conceptual and representational thinking have a role in trying to represent that which cannot be represented; that is, Spirit. Neither is alone adequate; both are necessary. More broadly, his dialectical intention is evident throughout his entire philosophical system.

I learned that Hegel's hierarchy of art forms (from architecture, sculpture, and painting, to music and poetry) corresponded to his hierarchy of religions. This progressivist model assumes that each age expresses a particular Zeitgeist, or spirit of the time. For instance, primal religions of nature in Egypt developed symbolic arts, where architecture dominated. The religion of beauty in Greece developed classical art, especially sculpture. As the consummate religion, Christianity developed the higher arts of painting, music, and poetry. Just as he proclaimed the "death of God," "death of death," and "death of evil" at the end of his *Lectures on the Philosophy of Religion*, Hegel ultimately declared the "death of art," insofar as he insisted on the supremacy of philosophical thought and reflection as the fullest expression of Absolute Spirit.

All of these proclamations helped determine the agenda for later nineteenth- and twentieth-century thinkers. Hegel

particularly influenced late twentieth-century deconstructionist, postmodernist, and feminist discourse. Many of my own questions about the traditional supremacy of reason, the understanding of otherness, and the relation of theorizing to life and experience, are questions that found one definitive expression in Hegel's effort to create a unified philosophical system.

But Hegel was not content to acknowledge simply that unity, particularity, and singularity each have an equally important place. Fascinated by the relation of self and other, God and world, Hegel defended and affirmed unity and universality over plurality and singularity. He, of course, saw them in dialectical relation, but his agenda ultimately privileged unity over plurality.

Although there are problems with Hegel's privileging of unity over difference, his insistence on thinking-in-relation found particularly suggestive form in his writing about the self and other. For Hegel, just as the world is God's other, and hence necessary to God's self-unfolding, the other person is at least implicitly constitutive of the self. "I have my self-consciousness not in myself but in the other," he wrote in his 1827 *Lectures on the Philosophy of Religion.* "I am satisfied and have peace with myself only in this other—and I am only because I have peace with myself; if I did not have it, then I would be a contradiction that falls to pieces." For Hegel, the other, in love, is what allows the self to be whole. From his oppositional understanding of self and other as master/slave in *Phenomenology,* to the role of the other in self-identity, Hegel cleared a space that has been especially developed by contemporary philosophers.

From one standpoint, Hegel offered an orthodox Lutheran interpretation of God as having reconciled the world to

himself once and for all. Yet in his 1827 *Lectures,* he also held to a more radical understanding of Spirit as process and activity. "Spirit, if it is thought immediately, simply, and at rest, is no spirit; for spirit's essential [character] is to be altogether active. More exactly, it is the activity of self-manifesting. Spirit that does not manifest or reveal itself is something dead . . . It is living, is active, is what it makes of itself." I take this notion that Spirit is activity to be one of Hegel's most significant formulations. How are we humans to partake of, experience, and manifest this activity of Spirit? In artistic creativity, religious devotion, and philosophical speculation, Spirit is expressed in and through the human spirit.

Many artists would not care that a nineteenth-century philosopher had identified art as an avenue for manifesting divine spirit, but Hegel's ideas coincided with my own intuitions about the power and role of art. It has been satisfying to encounter a philosophical mind that could articulate such ideas.

You undoubtedly hold a basic philosophy of life, but it may be unarticulated. I recommend that you bring your philosophy of life into consciousness. Try to say what it is. Develop awareness about the source and motivation of your actions. You will undoubtedly wrestle with the role of social norms, measuring them against your individual conscience. When I was younger, I believed that we are obligated only to ourselves. But I did not understand then how race and class privilege operates in our culture. Now I believe that we are answerable and responsible to others through all of our actions, including creativity. What is *your* worldview, your general conception of the nature of the world? What values do you hold dear? Answering such questions may be your first step toward articulating a philosophy for your art and for your life.

8

CHOOSE A PHILOSOPHER

Engage deeply with the thought of another, or with
the literature about particular topics that interest you.
Read everything you can find about Vedanta, voodoo,
or Volkelt. Choose topics and writers that most inspire
your curiosity.

As Hegel taught me, we think best when we think-in-
relation, when we connect our reflections to others' ideas
and to the world. In isolation, you may develop a false and
grandiose notion of the importance or uniqueness of your
musing. Alone, each of us could probably begin to articulate
a philosophy of art that makes some sense. But the effort to
develop a coherent understanding of why you make art, and
of what purpose your art will serve, will be rewarding. Just
how might you build a philosophical base for yourself? For
this process, I recommend choosing a philosopher whose
ideas have some appeal to you. It almost does not matter
which philosopher or group of philosophers you choose, as
the point of this lesson is to engage an interlocutor—some-
one who will help you create an internal dialogue about life
and art.

I have found tremendous inspiration in the ideas of a diverse group of Russian philosophers. In fact, if I were not an artist, I might be a philosopher in the traditions of Vladimir Solovyov (1853–1900), Sergei Bulgakov (1871–1944), Nikolai Berdiaev (1874–1948), and Mikhail Bakhtin (1895–1975). Like Solovyov, I would write discourses about the power and meaning of spiritual and erotic love. Like Bulgakov, I would write about the divine feminine, Sophia, or about how words are not merely symbols of meaning but have animate presence. Like Berdiaev, I would write about the ethics of creativity and about three kinds of time—cosmic, historical, and existential—centering my reflection on existential time, where creativity and ecstasy commingle. Like Bakhtin, I would write about the formative role of the other in constituting the self and about the intrinsic connections of art and life.

Of these four philosophers, I have spent the most time analyzing Bakhtin's ideas. His moral philosophy has affected my worldview and ethos. Unlike Solovyov or his contemporaries Maurice Merleau-Ponty and Henri Bergson, Bakhtin's goal was not to create a moral or philosophical system. I read his essays like fragments of a monumental sculpture that lies in pieces on the ground and must be studied for its coherence and meaning. Most of his essays are based on the presupposition that the human being is the center around which all action in the real world, including art, is organized. As in the work of Martin Buber and Emmanuel Levinas, the "I" and the "other" are the fundamental categories of value that make all action and creativity possible.

In a surprising way, studying Bakhtin's ideas helped me look with fresh eyes at a group of impressionist paintings by Claude Monet, which he painted during three journeys to the Mediterranean between 1884 and 1908. Although I had

lectured on Monet and other impressionists in nineteenth-century art history courses, I never felt the kind of passion toward his work that I feel, for example, toward the Russian avant-garde or toward contemporary art that is wrestling with the impact of new technologies. For years I have been convinced that it is very hard to see Monet's prodigious production outside of its commodification. If an artist's work is well known and well circulated through T-shirts, baseball caps, cookbooks, wrapping paper, and the like, what happens when we look at the "real thing"? Is it any longer possible to view Monet's art with fresh eyes?

Monet's first Mediterranean journey took place in 1883 and 1884, to Bordighera on the Italian Riviera, for ten weeks. Monet took this trip on impulse with Pierre-Auguste Renoir and concentrated on two motifs: the sea and the Mediterranean light. The second trip was in 1888, when Monet went to Antibes. It is not clear why he took the trip. He spent most of his time alone, choosing as his main theme the relationship between what is paintable and what must remain unpaintable. In letters he wrestled with several problems: with his serial procedure (painting more than one picture of a subject from different vantage points and under differing circumstances); with the issue of the relative incompleteness of his work; and with how his happiness was linked to his identity as an artist. The third trip was in 1908, to Venice. By this time Monet was heading a considerable business, which included international sales of his paintings, especially in the United States. One hundred twenty-five paintings survive from his three sojourns to the Mediterranean, and most of them were small enough that he could pack his canvases under his arm, as he set out for the villa garden, the shore, or the canal.

I have found three of Bakhtin's ideas helpful in analyzing Monet's painting—answerability, dialogue, and unfinalizability. Consider, first, his concept of answerability, the idea he used to describe the relationship of self and other. This notion—that we are answerable, indeed obligated, through our deeds—is the basis of the structure of the world and the basis of the artist's creative activity. Bakhtin's interpretation of creativity focuses on the profound moral obligation we bear toward others. Such obligation is never solely theoretical, but is an individual's concrete response to actual persons in specific situations. Because we do not exist alone, our creative work is always answering an other. Answerability contains the moral imperative that the artist must remain engaged with life, that the artist *answer* life.

To what extent can we speak about answerability in Monet's painting? Answerability, as responsibility or moral obligation toward others, expressed as an individual's concrete response to actual persons in specific situations, does not seem to have been Monet's concern. He was not concerned with how art was connected with life or with the theoretical implications of his painting practice. His attention was turned more to issues of his own commercial success than to such specifically ethical concerns; indeed, the business of art and personal profit greatly influenced Monet's artistry. Thus, although we might not be able to speak of answerability in the sense that Bakhtin used the term in the early essays, we can acknowledge that there are dialogical aspects to Monet's work.

With this second concept, dialogue, Bakhtin had in mind at least three distinct notions, as Gary Saul Morson and Caryl Emerson have shown: (1) that every utterance is by nature dialogic because it requires a speaker and a listener/responder in

a unique situation, (2) that such dialogue can be either mono-logic or dialogic, and (3) that life itself is dialogue.

At the most fundamental level, Monet engaged in an in-ternal dialogue with the physical world that then formed the motifs for, and pictorial elements in, his paintings. Physical elements such as the light and wind, the vegetation, the mountains and sea, and palace facades functioned as his in-terlocutors. Monet also engaged in a dialogue with the past, especially with those artists who dealt with the Mediter-ranean, as well as with his contemporaries such as Renoir and Berthe Morisot, among others. His dialogue with his second wife, Alice Hoschedé, was extremely important. Yet, although Alice may have been his primary dialogical other, we must not underestimate the formative effect of Monet's dialogue with another group: his critics and dealers. This range of dialogues shows that the self is never autonomous, but always exists in a nexus of formative relationships.

Although Bakhtin's discussions sometimes lack clarity, his reference to monologism means that dialogue can become empty and lifeless. To be truly dialogic and polyphonic, dia-logue must take place through paradoxes, differing points of view, and unique consciousnesses. Communication and so-cial interaction must be characterized by contestation rather than automatic consensus.

Can we read brushstrokes themselves as polyphonic? Isn't there a unique kind of visual contestation of color or of directionality that expresses a dialogic and polyphonic sensi-bility—where rose and blue and gold meet and interact? Or, isn't there an implicit dialogue in Monet's serial procedure itself, where he painted the same scene under differing con-ditions, seeking to show that perception is never singular? In Bordighera, Monet painted from slightly different vantage

points, showing objective differences such as weather, lighting, the sea, and vegetation; formal differences such as size, finish, and color; and subjective differences in mood. In Venice he began to try new approaches, searching to eliminate time as a variable in his paintings so that he could concentrate on the interrelationships between the atmosphere, light, and color. Monet altered his original serial practice (painting more than one picture of a subject from different vantage points and under differing circumstances) by painting the same place at the same time each day.

Polyphony presupposes that life itself is dialogue. As Bakhtin wrote in *Problems of Dostoevsky's Poetics:*

> To live means to participate in dialogue: to ask questions, to heed, to respond, to agree, and so forth. In this dialogue a person participates wholly and throughout his whole life: with his eyes, lips, hands, soul, spirit, with his whole body and deeds. He invests his entire self in discourse, and this discourse enters into the dialogic fabric of human life, into the world symposium.

Dialogue, therefore, is epistemological: Only through it do we know ourselves, other persons, and the world. Monet's dialogue at this level has indeed left us a considerable legacy of perception and knowledge about the world.

Unfinalizability is the third concept in Bakhtin's writing that has been useful in relation to understanding Monet. Bakhtin most clearly expressed the meaning of the term in his paraphrase of one of Dostoevsky's ideas. "Nothing conclusive," he wrote, "has yet taken place in the world, the ultimate work of the world and about the world has not yet been spoken, the world is open and free, everything is still in

the future and will always be in the future." In Bakhtin's formulation, this sense of freedom and openness applies not only to works of literature and art, but it is also an intrinsic condition of our everyday lives. Such creativity is ubiquitous and unavoidable, and for Bakhtin it should not and could not be separated from one's responsibility toward others and toward the world.

Clearly, the concept of unfinalizability does not help us to specify further differences in the levels of completeness in Monet's painting or between the etude and the tableau. (The Monet scholar John House has written extensively about the problems with Monet's "finish" and "finishing.") But I think the concept does offer an inclusive concept for thinking about Monet's larger agenda. When is a work finished? Can it ever be truly finished? When is a critical perspective or audience reception complete? As Joachim Pissarro noted, Monet preferred to call his paintings "completed" rather than finished. In a letter written to his wife, Alice, in 1894, Monet called them "works that I decide not to touch again." Such language suggests that he intuitively understood this insight. The fact that Monet's paintings continue to generate scholarly and public interest also verifies the central insight of Bakhtin's concept.

What *can* ever be fully finalized? There always is a tentative quality to one's work, one's action, and to life itself. Unfinalizability refers to at least two distinct levels: the ways we need others in order to finalize the self; and the ultimate unfinalizability of all things, events, and persons. Art and life are ultimately open-ended. Even though a person's life is finalized in death, that person's work lives on, to be extended and developed by others—an insight we certainly know vis-à-vis Monet's work.

The creative process, too, is unfinalizable, except insofar as an artist says, somewhat arbitrarily, "I stop here." Monet's use of seriality, including the ways he began to change his process, emphasizes the uniqueness of each moment and each painting in terms of subject matter and time, aspects such as time of day, weather, wind, light, season, color of the sea, tidal level, and other perceivable details. His decision to stop could never be final and conclusive, and this was something he wrestled with throughout the later decades of his life. Some Monet scholars dismiss his Venetian paintings because he did not stop soon enough! But precisely because it is always open to change and transformation, artistic work can be a model for the possibility of change in the larger world outside the studio. Indeed, unfinalizability gives us a way to speak about the problems of representing our constantly evolving world through the lens of our diverse and ever-changing subjectivities. The fact that Monet's life work seems to be, at least from one standpoint, about representing that open-ended flux is certainly another part of its enduring legacy.

Bakhtin offered me a language to define aesthetic values and ethics in relation to artistic practice, as I have tried to show in talking about the worlds that Monet and Bakhtin inhabited. Each man expressed, in his art (if not always in life), a profound optimism, a benign view of the world, a thorough lack of gloom, even under conditions of economic or political adversity. Monet's letters may express his effort, his discontent, his struggles, his fears regarding whether or not his paintings were adequate to the tasks he set. From the 1880s, they do not represent the pervasive industrial changes of the period—the chimneys and smokestacks, the factories and stultifying labor the population was forced to

engage in, or later, the Great War. Bakhtin lived in exile in Siberia through the worst parts of the Stalinist repression, forced to work in relative obscurity as a bookkeeper and high school teacher, while some of his closest intellectual colleagues were murdered or sent to die in the gulags of the Russian Far East. In our world, their optimism can be refreshing. Whether it be the long northern winter or the blistering southern summer, republican democracy or totalitarian regime, the threat of terrorism or of lawless anarchy, we need visions of the light and reminders that all of life is and must remain open to dialogue, change, and transformation.

Philosophy can be esoteric, or it can speak directly to you, to your dreams and longings, your questions and vision of the world, and your comprehension of art. Browse the shelves of libraries and bookstores. Scour all of the media that are accessible to you. Seek, says the ancient proverb, and you shall find.

9

THEORY

Ignorance may be bliss, but knowledge is power.
(These are clichés, but still worthy of reflection.)
Learn about theories because they help you to see the
world—other people, history, nature, and all of their
complex interrelationships—in new ways.

Ours is the age of theory, especially in the academy. I some-
times wonder if the late twentieth century will become
known as the age when theories came of age. Not just a time
of philosophizing, but of theorizing about all aspects of so-
cial and personal life. I would never dismiss this impulse to-
ward the theoretical, for theories seek to explain and criticize
the world. A theory seeks to explain a particular phenome-
non or set of phenomena. Let me give you an example.

Earlier I wrote that feminism is an example of an ecological
theory. Like ecology itself, feminist theories seek to show con-
nections between aspects of our lives that are often separated
and to demonstrate the unexpected connections of personal
life with complex social, political, and economic processes.

Describing what feminist theory is, however, contains
subtle dangers. In explaining feminism and the feminine, I risk

turning myself into a slogan. Identity politics might seem more important than lived experience. I became self-conscious of my female identity in the era when "the personal is political" was stridently proclaimed by the women's liberation movement. Simultaneously, I scoured world mythologies for stories about female deities and the "eternal feminine." While studying goddess theologies, or thealogy, I also learned about the differences between sex and gender. Reading French feminists who are often criticized for their essentialism, I became aware that women of color and poor women do not share middle-class white privilege and experience. Feminists in the developing world, third-wave feminists, and postfeminists have further shaped how feminist theory is evolving. Thus, contradictory views and highly divergent voices about feminism and the feminine have shaped my worldview and ethos.

It is possible, indeed probable, that difficulties in defining my vocation are related to my gender and class location. I am a woman with European working-class roots; my family is that typical "American" combination of people who immigrated to the United States from various countries—in our case, from Ireland, Scotland, England, and the former Czechoslovakia. In the new country men had more opportunities than women, who generally assumed traditional roles. Although parts of my family settled in the Midwest, both of my parents grew up in California and sought a home in the Pacific Northwest before I was born.

I grew up in a suburban ghetto in a secular humanist family with both bigoted and progressive wings. My paternal grandfather was notable for his racism; my mother was a defiant liberal humanist. In our class context, women were not required to define a vocation for themselves; they only needed something to "fall back on," as my father put it

when I was seventeen years old. How I resented his attitude and lack of encouragement for an intellectual and artistic life. I could describe my mother, long an institutional invalid, as having succumbed to the horrors and terrors of patriarchy, including the institutions of marriage and compulsory childbearing. While still quite young, I determined for myself that problems lay ahead.

My family is riven by what my sister Catherine calls "cut-offs," breaks in the continuity of relationships that have affected the women, and the men. Divorce, disowned children and siblings, suicide, broken connections to the past and to places of origin: These are common in my family story, perhaps in many "American" families. As a female heir to such stories, I have felt a keen imperative to understand more about the determinative roles of sex and gender.

As a young girl in the 1950s and early 1960s, I pulled from the bookshelves my mother's copies of Simone De Beauvoir's *The Second Sex* and Betty Friedan's *The Feminine Mystique*. I early rejected traditional feminine stereotypes and affirmed a more androgynous identity. I formally "discovered" feminism in 1975 when I participated in a consciousness-raising group at the Lindisfarne Association in Southampton, New York. During the 1970s, my feminist consciousness began to flower, as I wrote passionately about reclamation of female identity, created myths and images about my birth and early years, and developed visual images for my experience. I took a course titled Women in Art, taught by poet Olga Broumas. I studied feminine psychology and made art with three artists—Mollie Favour, Dyan Rey, and Sharon Ungerleider. As a young feminist, I fully embraced the essentialism of the time. Feminine and masculine principles defined the poles of experience, although I knew and wrote that "the feminine

is neither the exclusive domain of women, nor the masculine principle of men."

Until the mid–1980s, I intermittently created art projects concerning my identity as a woman, and then, from 1984 to 1991 I studied feminist theory, theology, and thealogy (among other disciplines) at Harvard Divinity School and Harvard University. Although I had taught a course titled Women in the Visual Arts in the late 1970s, it was not until 1991 that I began teaching about issues related to gender, race, and representation in contemporary art. Working as the director of a women's studies program between 1996 and 1998 provided further opportunities to refine my understanding of first- and second-wave feminism and to consider the emergence of new third-wave and postfeminist discourses among younger women. All of this led me to the conviction that women and men must continue to identify ourselves as feminist.

This is part of the history, or herstory, that shaped my understanding of selfhood and female identity. But I also learned that the ability to grasp, shape, or create a self is not openly and equitably available to all. Such grasping, shaping, and creating imply relationships of power—of subordination and domination—that relate to the practical issues addressed by feminists. Our origins in the barrio or inner-city ghetto, in working-class neighborhoods, in middle-class suburbia, or in aristocratic enclaves, as well as whether we are women or men, have everything to do with our ability to shape and create reality. Even religious systems must be examined for their role in this process.

Valerie Saiving, in one of the earliest feminist critiques of religion, argued that positing a single form of sin did not make sense, because women sin more through self-negation,

through giving up and sacrificing the self, than through self-assertion, which is more common among men. This is especially pertinent for women artists who face difficult decisions if they want to have children. Parenting contains its own imperatives, including self-sacrifice. New notions of individuality and of the self are needed in which such self-giving does not constitute loss for the female artist.

What I have described here is a socially and culturally constructed interpretation of feminism. It is very different from a feminine essentialism that claims to know the true and universal nature of "woman." I could not say that I am a woman and therefore I necessarily feel or think or act in a particular way. But I am willing to describe how my gender is linked to ethnicity and race, class and sexuality, age and ability.

As a woman, I experience oppressive social institutions that refuse to regard my contributions as valuable and that do not allow me to make responsible choices. I also benefit from my racial and ethnic identity. As a woman of European descent, I have more access to the institutions of power than do women and many men of color. True solidarity with others means that I do not assume a blanket commonality of experience, but that I recognize how privilege accompanies race, ethnic origin, and skin color. While my origins are working class, I live with middle-class expectations and amenities. Recognizing that social origins are extremely diverse, I realize that issues of concern to feminists such as myself may be very different from those of women from poor contexts in both the developed and developing worlds. I have also pondered what Adrienne Rich called "compulsory heterosexuality" and the "lesbian continuum," and have resisted attempts to define my sexuality. At midlife, I am keenly

aware of physical limitations, but also experience the stamina and vision that evolve with age. Respect for and willingness to listen to and learn from difference is vital to me. Such values have evolved from my engagement with feminist theory.

The world is alive with theories, but where do they lead us? During the twentieth century, wave after wave of feminists were responsible for helping women gain voting privileges, for promoting equal pay for equal work, for supporting reproductive rights and choices, and for a range of other specific social goals. What will be the legacy of this work in the twenty-first century? Regardless of whether you are a student of art or an older working artist, you are and will be part of the answer to that question.

DISCIPLINING THE BODY

10

TAKING YOUR SEAT

Commit yourself wholeheartedly to your regular
artistic practice. Do not be afraid of commitment and
do not get into the habit of procrastinating about your
work. This is what it means to take your seat.

Consider the metaphors of depth and breadth. Ex-
plore the breadth of the arts and the breadth of your
abilities, but let your ideas guide you toward the most
appropriate vehicle. Work from the depths of your soul.

In *A Path with Heart* Jack Kornfield describes a phrase used
by his teacher Achaan Chah: "Take one seat." To take one
seat means choosing one practice from among the many dis-
tinct spiritual practices of various traditions. It means being
willing to sit down, focus on your breath, and encounter
yourself on a regular basis. It means, more than anything
else, being present, practicing.

The artist, too, must find and take a seat. However, find-
ing is not the same as taking! In order to find a seat, a
method of working that suits you, you have to explore. Ours
is a consumer culture that makes it exceedingly easy to shop
around. We are encouraged to try this, and try that. It is

tempting to make this eternal process of trying the new into a permanent way of working. In art schools and universities, the process of finding your way is made easier, because courses in various artistic disciplines are taught regularly. Working on your own, it is more difficult, for few of us can afford welding equipment, ceramic kilns, *and* a state-of-the-art computer lab.

But regardless of how you learn about the range of materials and techniques in the visual arts, eventually you will say, okay, now what? This is the time for taking your seat, for settling into the process of finding out what you have to say and what media are most appropriate.

I find a useful metaphor for this process in the chair itself. Some years ago when I accepted my first administrative position, I began to construct small chairs using basswood, glue, acrylic paint, gold leaf, beeswax, and found materials such as shells and old books. I made several "Didactic Chairs." An "Endowed Chair" contains a small movable text, "The vocation of the artist is the reclamation of the future." I also created a series of "Computer Chairs" called "Mercy Seats," named after an archaic name for the throne of God. Two "First Chairs" make explicit the fact that the mother's lap is the baby's first chair. A variety of others are more difficult to categorize. Over the years of making these small sculptures, the chair has become a powerful image for me.

The chair is like a body. It has legs and arms, a back and a seat. Your body is your chair, the original *asana*. *Asana* is a seat on which one sits or any comfortable posture that can be maintained for a long time. It developed from the crouched position common among people who prefer not to use chairs. Therefore, the body is not just *like* a chair, it *is* a chair. This insight, which seems so basic, gave me tremen-

dous inspiration for creating the series, and for the creative process in general.

Each small sculpture is a meditation—on dialogue and the way power operates to structure our ability to speak openly and honestly to others, on hierarchy and privilege, on striving and upward mobility, and a meditation more specifically and literally. When we meditate, we sit in silence, and in our world, silence is rare and hard to achieve.

Now, I sit pensively beside the James Creek, where I live in the foothills of the Colorado Rockies. A hawk circles directly overhead. The wild geranium I have uncovered is in full bloom. A cloud becomes a youthful face, partly obscured in shadow. Endless ripples of crystalline water against old stone bring me into the present moment.

I have taken my seat, made a commitment to observe the world and listen to myself, and to give form to what emerges. If you are unwilling or unable to do this in your own way, then I recommend closing this book and trying again on another day.

11

THE STUDIO

Create a space, a studio of whatever size, in which to work. Construct a tool kit, if you must be itinerant, and take it with you wherever you go.

Learn self-discipline. I knew an artist once who had the privilege of spending every morning in his studio, painting. This does not guarantee greatness, but showing up does mean that you will have time to create.

You will not find your own voice and vision unless you are present to yourself. Go regularly to the studio, or to your kitchen table, or wherever you have designated as a workspace.

Sometimes a place comes first, before you know that you want to work in the arts or become an artist. Sometimes a place is instrumental in shaping your aspirations. So it was for me.

I came late to the visual arts, if age seventeen can be called late. I had just returned from a momentous trip to Russia and learned that I was three months pregnant. Although I completed a successful fourth year of Russian study and a first year of coursework at the university, I turned to

drawing and design during the lonely period of my pregnancy. One day, mid-year, I accompanied my friend Mardi on an expedition to the ceramics studio in Lawrence Hall. She showed me her latest creations and introduced Steve, who was throwing pots. Having never seen a clay studio before, I was intrigued by the flurry of activity. Shortly after that initial visit, I convinced one of the professors to let me into an already overcrowded ceramics class. Earlier intellectual aspirations and career plans had lost their resonance, and I longed to reconnect with the physical world. The ceramics studio became my haven.

Even in the era of production pottery, and the department emphasized this, I used my engagement with clay and earth materials and fire to study geology, chemistry, astronomy, and physics. Ceramic processes opened a way out, into, the greater world. Simultaneously, I began using clay to create objects and images dealing with the inner world, dreams, and the spirit.

Our studio was located in the old university physical plant. Known as 190 Lawrence, it contained numerous small rooms on several sides, like appendages on a crustacean. In one recess were large concrete bins filled with clay. We mixed this clay by hand from hundred-pound bags of various powdered clays, kaolin, bentonite, feldspar, alumina, and silica. The clay was supposed to age in the bins, but it was always used before developing enough elasticity.

In the basement we stored other materials used for mixing clay and glazes—barium carbonate, whiting, cobalt, tin oxide, zirconium. Faculty members and graduate students had cubbyholes, and there was a small common room for lunchtime conversation and seminars. Sets of drying shelves divided the room into spaces for different uses. Clay bins

were separated from the kickwheels, which occupied the center of the largest room. Tables for hand-building were in another area. Two or three electric wheels stood along one wall. What an inspiration it was to watch Bev Murrow throw "off the hump," making many small pots from one massive lump of clay on the wheel.

The studio was open day and night, seven days a week. During that first tentative visit to the studio, I decided that I had never seen such a dusty and encrusted place, yet with evidence of human creativity everywhere. Later, when I was paid to maintain order in the shop, I faced my first painful lessons in entropy, the tendency of all things to move toward disorder. Yet I became a regular. I came on weekends and in the evenings to throw, trim, pull handles, paint slip, experiment with glazes, and increasingly, to fire the kilns. A new language needed to be mastered: bisque, stoneware, flux, feldspar, red heat, cone ten, pilot, convection, and radiation. When all four gas kilns were alight, the kiln room was like a sauna.

Suddenly the mysteries of the physical world opened up for me. Geology was not an abstract science. A cut in the roadside might yield clay. Clay has special properties; it is ever malleable. If the shape of a pot is not right, another can be made. If greenware hardens, it can be soaked down in water. If bisque is fired and not yet glazed, it can be ground up for grog. If fired to 2,300 degrees Fahrenheit to become stoneware, it can only be broken into shards and recycled as rock. There was a direct connection between those shards and stone from the local basalt columns, which we ground into powder for glazes.

That first visit to the studio sealed my fate, or so it seems in retrospect. My teacher David Stannard never wavered in

his assertion that a crucial dimension of studio practice involved finding out for oneself what one wanted to do. Many students found his refusal to give direction through specific assignments discomfiting, but for me his approach was liberating. Later, with Bob James and George Kokis, and with visitors such as M. C. Richards, Paulus Berensohn, and Paul Soldner, I continued the process of finding my way with clay, to paraphrase the title of one of Berensohn's books.

Learning to question and "following one's nose" don't make for the easiest path, because signposts along the way are not defined as clearly as when one uses a map. Following one's own path is rewarding, and fosters courage to face the unknown, willingness to take risks, and confidence in oneself.

Having a place to work, finding a studio, may be a significant experience for you, as for me. Therefore, be alert to your surroundings. What kinds of places call out to you? Find a studio, any studio, in which to work. Define a corner of your kitchen or office as your workspace. Even if your responsibilities—parenting, caring for elders, employment—make it hard for you to have extended time in your chosen workplace, do not despair. Traditional models of the male artist in his studio have carried the unspoken assumption that he could just leave other responsibilities whenever desired and close the studio door. But whether you are female or male, if you have disparate demands on your time and attention, available time to work in the studio will probably be fragmented. Perhaps it will be confined to weekends or shorter irregular periods. Nevertheless, go there regularly. Take your seat in the studio and begin to work.

12

KNOWING THE WORLD

Learn about others through reading, dialogue, and the media, but especially, find opportunities to know the world through travel. Only by getting to know other people directly can you counter pervasive ideologies of the enemy.

Be voracious in your appetite for art. I would even suggest that you can be indiscriminate. Look at everything, from art in the world's greatest museums to street artists hawking their wares. Develop your own aesthetic sensibility by looking.

If you have the proclivity, study a foreign language, for it will give you deeper access to other people and their culture.

What might it mean "to know the world"? And just how do you get to know the world? Through observation, through being in the world, and listening and opening the senses. Through travel, literature and film, through meeting people, listening to the news media. We study cultural traditions and history in order to know the facts of history, geography, and so forth, and in order to interpret events. But to know the world is also to engage deeply with places and

people. This chapter and the next deal with two aspects of knowing the world. This chapter is about travel and, in particular, the encounter with cultures different from my own; the next is about the natural world. Some people find their home through travel, where peripatetic wandering becomes a way of belonging. I have traveled intermittently, and highly recommend it to you.

Earlier I described Monet's three sojourns to the Mediterranean. Robert Henri returned repeatedly to Ireland in the early 1900s, where he painted a lovely series that he titled "My People." Richard Long has traveled extensively, making art out of walking, moving stones and wood, and conducting private rituals. Betsy Damon has worked in China on massive long-term environmental projects. Ann McCoy works intensively with a museum in Poland. In short, many artists not only find that travel is congenial to their work, but it also shapes their understanding of others and different cultures.

Sometimes we react to otherness and difference with xenophobia and the desire to dominate, which has led historically to the imperialist ethos. At other times we face another person with curiosity and the genuine desire to know. Yet, how do you actually get to know that which is radically different, especially if a person or culture has been deemed the enemy for much of one's life? This question has perplexed me for more than thirty years. How does one get to know "the enemy"? Perhaps the answer lies in listening, observing, and suspending judgment, in creating opportunities for dialogue, in asking questions and trying to comprehend the answers.

Each person is drawn to particular places on the planet. I love the Palouse Hills of southeastern Washington, the Greek

island of Samothrace, and the far eastern Primorye region of Russia. In fact, Russia grips my imagination.

Why does my consciousness pull and tug in this direction, toward Russia? I understand now that the answer concerns otherness and difference—the way the ideology of the enemy exerted itself into the deepest reaches of my psyche when I was young. In every era there are governments and people deemed to be "the enemy." Of course, if you study history, you will see how this designation changes. A country once called our adversary turns out to be our friend after all. People whose labor was the object of derision become our partner.

I was born during the Cold War. At school in Seattle, students were routinely subjected to air-raid drills. We ran to the basement of the large elementary school, where we squatted under tables, hands covering our heads. At home, dinnertime conversation covered manners and morals, against a backdrop of anti-Communist rhetoric. I did not know about Joe McCarthy's congressional investigations until my teen years, but the influence of his ideas seeped through the walls of our house and into the kitchen. For some, being surrounded by such an ideology leads to hate and distrust, but I was curious, even compelled, to learn about that strange land to the west across the Pacific.

In high school in the 1960s, I studied Russian for three years and argued disarmament issues on the debate team. I was a troubled adolescent; life at home was full of sorrow and pain and the encounter with madness. The outer world also was a place of strife: U.S. involvement in Vietnam had begun. At the time, I thought that significant work would involve international activity such as disarmament negotiation.

In fact, my attraction to Russian culture—to its art, music, literature, philosophy—began during those teen years.

Wassily Kandinsky was the first artist whose paintings I wanted to copy when I began taking art classes in high school. As a young teenager, I played flute in Seattle's youth symphonies, where the regular repertoire included Prokofiev, Shostakovich, and Tchaikovsky. I read the poetry of Yevtushenko and Voznesensky; in fact, Voznesensky's "make love, not war" demarcates the 1960s in my imagination. Hearing him read this poem while protests against the Vietnam War raged on my college campus remains a vivid memory. In eleventh grade, we had read Leo Tolstoi's *Anna Karenina* and *War and Peace*. Only years later did I find his passionate short essay, "What Is Art?" and the essays on aesthetics by Nikolai Berdiaev and Mikhail Bakhtin.

Given these interests, it is no surprise that when I learned from my Russian teacher about a unique opportunity to spend the summer following high school on an international exchange, I desperately wanted to go. And go I did, to a Russian institute in Unterweissenbach, Austria. Twenty-five students from the United States attended classes every day. We worked hard at our desks, memorizing grammatical rules and pronouncing faltering sentences.

One hot July day some of the institute students decided to visit a former Nazi concentration camp located nearby. I remained in town, though not because I didn't care about or know what the Holocaust meant. Even then I felt, to paraphrase Jean-François Lyotard, that the twentieth century had given us as much terror as we can take.

Finally, our group went for eight precious days to Russia—to Kiev, Leningrad, and Moscow. From my room in our Kiev Intourist hotel, I looked out on a view of old buildings and broken vehicles that reminds me now of Bombay and Calcutta. Late one afternoon, classmate David Campbell and I took the trolley to the end of the line in a residential

neighborhood. We wandered along a dirt road; it was my first glimpse of where Russians actually lived. I went alone the next day to a bookstore and scoured the shelves for a collection of Vladimir Mayakovsky's poetry. When I couldn't find any, I queried the clerk, who looked at me inscrutably. "*U nas net evo stikhov*" (We do not have his poems). Later, I learned that Mayakovsky had been blacklisted, publication of his autobiography forbidden, and that his writing had generated considerable controversy.

In Kiev, we also went to lesser-known sites such as Babii Yar, where Nazis murdered thousands of Soviet Jews during World War II and which is commemorated in Yevtushenko's poem of the same name. What suffering emanated from the ground, and how inconsequential and impotent I felt. Later that evening, when David and I fell into conversation with two young soldiers on the street, I was impressed by the fact that we were profoundly alike. This was my first meeting with "real Russians," although they might have been from Soviet Tashkent or Vilnius, as much visitors to Kiev as we were.

In Moscow the grandeur of the architectural monuments was astonishing: Moscow State University, the Bolshoi Theater, Red Square, the Kremlin. We were proper tourists, standing in line to see Lenin's tomb in Red Square and shopping at GUM. But all of these buildings were historical documents too. For instance, the scale of the Young Pioneers' Palace impressed me greatly, and it became a reason for learning about the educational and ideological structure that moved young people through the Octobrists, Young Pioneers, Komsomol, and possibly into the Communist Party.

I have already written of the immense impact of my 1967 visit to the Hermitage Museum in Leningrad. My life as an artist really began in Russia, during that visit to the Her-

mitage, and during the year that followed as I grappled with the consequences of teenage pregnancy. I turned from Slavic studies to art, seeking a path through those grim years. In the late 1980s, I began to study Russian again in order to read essays by Mikhail Bakhtin that had not then been translated.

Suddenly, in the early 1990s, I also had opportunities to return to Russia. I went to Moscow for an international conference; and I went to Vladivostok to help organize exhibitions and artist exchanges and to write about U.S. and Russian art. During a decade of sustained engagement with people in Vladivostok, I have been able to create a bridge between my intellectual interests in Russian philosophy and art and my desire to connect with the lives of actual people.

One of the most memorable visits took place in June 1993. My colleague Ross Coates and I flew from Seattle to Vladivostok on the first Alaska Airlines flight into the city. Our journey was planned for one month, the timing chosen to coincide with the return of an exhibition to the Artetage Gallery. Located in the large marble White House that was the city's administrative center, Artetage was Vladivostok's first private art gallery, founded by Alexander Doluda and Alexander Gorodnyi. At the exhibition opening, I spoke in Russian to the large audience, trying to communicate the enthusiasm we felt about building a bridge between the Primorye and the Pacific Northwest. Doluda and Gorodnyi arranged for us to spend a week at Vityas Bay, a secluded site close to the North Korean border where one of the artists had a *dacha*, a "small country cottage." Without electricity or running water, without phones or television, I spent several idyllic days painting in a small shed and walking along the rocky beaches.

When Ross and I returned from that four-day visit to Vityas, an urgent message to call home awaited me. I learned

that my father had died suddenly and had already been cremated in Seattle. I prepared to return home early.

During our last day in Vladivostok, a large party was held at an artists' bar, located on the edge of the Amur Bay. It was a scruffy run-down place, crowded and noisy. We danced, paddled small boats in the bay, and drank toasts to our futures. In many ways, it was a joyous occasion. But late in the afternoon, standing alone on an old rickety pier that jutted into the bay, I wept. I mourned my father's death. I cried for the young girl whose adolescent dreams of working in Russia had been put aside when she became pregnant at age seventeen and relinquished her son for adoption. I cried out of joy for the miraculous processes that had brought me back to Russia twenty-six years after the first momentous trip.

My decision in 1967 to drop Russian and take up art was complex. In the years that followed, I was plagued by depression. I was not the "good enough daughter" that Alix Kates Shulman describes in her memoir of that title. I had failed because I got pregnant in the first place, failed because I did not fulfill my parents' educational and economic expectations. The years are passing now, since my father died. I am learning that I did not fail. Even when I was young, I had a prescient sense about things.

In May 1998, five years after my father died, I stood once again on that same pier where I had mourned his passing. This time, however, I gazed back at the artists' bar where my son Mitchell was having his own thoughts. Having first met him the previous year, I invited Mitchell to join me on this eight-day journey to visit artists and friends. Those days in Russia marked the initiation of a slow process of acquaintance that will take years.

I began by observing that place draws us, beckons us. Few places on earth have had the enduring power to call me back, again and again. Russia, which lives in my imagination even as it is located to the west across the Pacific, is, for me, such a physical and spiritual nexus. There, my destiny was shaped. From my visit to the Hermitage and my father's rejection when I returned from Russia in 1967, to his death while I was there in 1993 and the journey with my son in 1998, a fateful circle seems to have closed. There, I discovered my love of art and I affirmed my will to create. In this Russia of my imagination, I learned that life is a spiral and that dreams need not die.

Just what do you know after and through such experiences? Obviously, no one place constitutes the world, but each place is a part of the world. Identify the places that evoke your curiosity, that inspire and move you. You will know yourself, as you know the world.

13

BEING IN NATURE

Enter into an apprenticeship with nature, which means paying attention to and observing the natural world. Many of us know fairly well the constructed worlds of the city and town. But how many of us have learned the lessons of the seasons, of water, of the growth cycle of a single plant, or the habits of a garden snake? This knowledge will nourish your art.

Develop a relationship to the place where you live. This may or may not affect your art directly, depending upon what you decide to make, but it will thoroughly affect your emotional and intellectual life. Staying put offers powerful healing from the speed and transience of contemporary life.

Regardless of the sources of your art's content, who you are as an artist will be shaped by your relationship to the natural world. As artist Paul Klee put it, "For the artist, dialogue with nature remains a *conditio sine qua non*."

In talking about disciplining the body, it behooves us to remember that we are bodies in a physical environment. I therefore simply want to draw your attention to the physical

world. You live in the world of cultures, and you live in nature. Your body is nature, and is not separate from the physical world. Like the earth, you are made primarily of silica and water.

The word *nature* comes from the Latin *natura*, a verb form of *nasci*, "to be born." In nature we give birth to ourselves, to awareness of change and transformation. In nature we live and die. Raymond Williams has written that *nature* is probably the most complex word in the English language. There are at least three related areas of meaning: the essential qualities of something, the inherent force that directs all things, and the material world itself. When I talk about "being in nature," I mean this third sense—the physical world of phenomena.

The English philosopher Herbert Read once wrote that only those who have entered into an apprenticeship with nature should be trusted with machines. Just what might an "apprenticeship with nature" mean? It means observing the world, tending, and stewarding. It means staying put long enough to learn about the environment where you live.

It is often said that those who know only their own culture or their own time know very little. The same might be said about the natural world. Knowing the world actually involves much more than traveling or learning about other cultures. Knowing your environment means studying the elements that make up your place in the world.

When it comes to considering nature, I like to sit and simply to observe. I like to read what others have to say about nature and landscape. Their images and metaphors give me insight. A huge genre of such literature rewards ongoing reading. However, I find it impossible to write about nature, or to read about it, without wanting to be outside, in nature.

Make an inventory of the natural world close to you. What is it composed of? Is it urban, rural, or suburban? Can you name the edible weeds that grow where you live? How are the elements constituted? How do the winds change? From which direction do they blow? Where does your water come from? Not just from the faucet, but what is its source in nature? Find out where your watershed is. Where does your food come from? Note the characteristics of the earth where you live, the topography and geology, the trees and plants, stones and rocks, animals and insects. Why do these questions matter? I believe that who you are as a person and as an artist will be shaped by your answers to such questions.

What is the quality of the air you breathe? Is it smoggy, hazy, dusty, crystalline, dry, or damp? And fire. To me fire is a living element. For more than a decade I have lived in dry areas, where fire is a genuine danger. I am therefore careful in the winter when I burn last year's willow fall, those branches that snapped and fell during storms and high wind. I am grateful for the heat they bring to the studio where I write.

Observe the sky. I have always loved watching the changing sky. Blues, whites, and grays—from cerulean to ultramarine. Star dimples at night. I once said that if I could become any element in nature, I would be a cloud. Evanescent and transitory, yet present. Try using clouds for the so-called da Vinci exercise: find faces, animals, and things in their changing and ephemeral shapes. Watching the transmogrification of form will stretch your perception and stimulate imagination. Look at Georgia O'Keeffe's paintings of clouds and sky.

You might also want to study the work of artists such as Paul Cézanne and John Constable, whose paintings are vivid

representations of the natural world. Cézanne, for instance, made many paintings of the area where he lived, especially of Mont Sainte-Victoire, the mountain that overlooked the valley below. These extraordinary paintings made during the final phase of his career are splendid examples of his technique of representing objects and space from a multiplicity of angles. Or look at the work of Helen and Newton Harrison or James Turrell for a more contemporary interpretation of the relationship to the physical world. Turrell's Roden Crater in northern Arizona is a massive collaborative project that has been underway since 1974.

Try to be like the Greek god Janus, looking inward toward the hearth and outward toward the world. Consider how you discipline and might discipline your body. But look outward, toward nature, to consider where you are in a very literal way.

Consider the meaning of landscape. Natural phenomena constitute a complex and sometimes unreliable reality, as Anne Spirn has noted. Yet that very unpredictability is a powerful teacher. You will always create in an environment of risk, where facing the unknown is a constant challenge. Nature gives you practice with this.

Landscapes can be sites of worship, as at the forest of Ise in Japan, where ancient Shinto rituals are conducted. They can evoke powerful memories, as at Maya Lin's Vietnam War Memorial in Washington, D.C. For many of us, the landscapes of childhood and youth have particular resonance. For me, the sights, sounds, and smells of Puget Sound, the changing tides, views of Mount Rainer, which often seemed to hover in midair: All of these evoke particular memories of sorrow and joy. We play and congregate with others in landscapes. And landscapes are sites of work and

of home. The factory, office building, and school, as well as the mountains and the sea: Each expresses unique powers.

Like Aldo Leopold, I urge you to think like a mountain. Think about time, about stability and the utter stillness of being. Buddhists say "stand like a mountain": Be strong and stable and let the whirling clouds and winds enclose you, freeze you, and heat your core. The mountain, like other elements in nature, is a powerful metaphor for stability, solidity, and quiet. Have you ever sat still long enough to really observe a mountain? Mostly, what you will see is that the mountain itself is still amidst movement and life that swirls on and around it.

The pace of contemporary life and of much of our activity is very fast. It tends to cauterize the imagination. Running, bicycling, snowboarding, skiing—activities we think of as recreation—are all fast. Using digital technologies is an exercise in speed. Watching most contemporary film is an experience of action and violence. What, you must ask, actually frees the imagination and slows it down so that we can observe ourselves, others, and the world? Stillness and silence. Disciplining the body, in nature, can allow you to slow down, to become quiet and contemplative, to listen to sounds, and notice visual forms and patterns.

I have spent time this summer sitting, observing the habits of a garden snake that lives in my medicinal garden. It is shy, though occasionally it will not slither away when I approach, but will raise its head and flick its tongue, sensing and smelling me in that momentary pink flicker. I always feel blessed by these encounters.

Grow something. Plant a seed, a sunflower, a garlic clove, a tiny lettuce seed. Tend a plant. It will teach you patience. How long I have awaited the blooming of the snapdragons

and the unfurling of the datura trumpet. But I must wait. I learn to slow down, to enter another kind of time. And then, the few weeks when the plant actually blossoms are magical.

Begin to develop your visual memory. When Robert Henri was teaching in Philadelphia and New York in the 1910s and 1920s, he would give students the assignment of studying the model in one room, and then going into another room to draw and paint what they had observed. This is a superb practice for enhancing your visual acumen and for exercising the imagination. Nature can be your teacher using this same exercise.

Disciplining the body means taking your seat, committing yourself to particular artistic practices, going to the studio, being present, developing a critical and analytical perspective on your materials and media, choosing technologies appropriate to your ideas, and learning firsthand about others—other people, other cultures—and about the natural world. Without such practices, your art will be like a dandelion seed, wafting on the wind, looking for a place to grow.

14

THE TECHNOLOGY QUESTION

Become a media philosopher and a public intellectual, analyzing the impact of new media on your values, your body, the social fabric of which you are a part. This means paying attention to, analyzing, and criticizing the forces that shape contemporary life and using your intellect to help yourself and others interpret the world. Find avenues for making your views public.

Choose appropriate technologies to suit your ideas, rather than allowing technology to drive your creative process.

Consider carefully the nature and impact of the digital media you embrace. Use these media consciously and critically.

Drawing and painting, ceramics and stone-carving are ancient artistic technologies. Photography, film, and video are newer technologies, although the origins of photography date back to the early nineteenth century in Europe. The digital arts are the latest addition to the media repertoire available to you as the artist. It therefore is incumbent upon you to think critically about this question of technology. Many

of you may find yourselves sliding unconsciously into using the latest new technologies as they become available, simply because they are there.

Technology derives from the Greek word *techne*, which was originally synonymous with *art, skill,* or *craft.* Each of these words now has its own etymology and cultural meaning. I use the term *technology* broadly, to designate the process or method that you choose. Here, I mean to draw your attention to the problematic character of new technologies and to pose a crucial question. What vehicle, what medium or technological apparatus, is best suited to your ideas?

Besides offering new solutions to problems, technological revolutions are also games of seduction, and betrayal, for the immediate gains of new technologies are often followed by long-term liabilities. As Theodore Roszak has noted, neo-Luddites repeatedly remind us that automobiles facilitate transportation, but they deplete the store of nonrenewable natural resources, pollute the air, and destroy urban integrity. Medicine cures many diseases, but leaves us with ever-more resilient viruses, an upward spiraling population explosion, and ethical dilemmas surrounding the beginning and end of life, dilemmas around genetic engineering, abortion, and euthanasia. Computers process enormous amounts of data, but destroy our privacy, concentrate commercial control of information in the hands of a few multinational corporations, and mesmerize us with a pervasive consumer ethic that effectively seduces and controls us through pleasurable entertainment. The latest technological breakthrough cannot and will not be a panacea for all or even some of the world's ills. Technology cannot fix what is already wrong, because it tends to create its own problems.

What kinds of artistic responses could possibly be adequate to such challenges today? Artists' responses to technology

differ widely, ranging from embracing the latest technologies to refusing, in a variety of ways, to engage change at all.

The benefits of working with newer technologies include possibilities for inventing new forms and for analyzing our present cultural challenges. Artists such as Mark Amerika, Margot Lovejoy, Mike Mandel, and Adrianne Wortzel are exploring this arena. The invention of internet art, for instance, presents exciting opportunities for artists to make their creative work available to people all over the globe who have electronic access. Creating imaginative narratives that juxtapose the personal and the historical, that combine visual and verbal language, and that are available to a wide audience offer new possibilities for understanding cultural difference and identity.

The risks or problems of new technologies include lack of resources for expensive materials or lack of access, as well as the dominating character of the technologies themselves. My present university has a policy of providing its teaching and research faculty with new computers on a regular cycle. But what about others, whose institutions or personal means do not allow for such upgrades? The so-called "digital divide" of the late twentieth and early twenty-first centuries names this disparity in available resources.

Among artists who reject technology, some stalwartly believe in the importance of the handmade and traditional practices. Nancy Pobanz, for example, creates one-of-a-kind books using paper and pigment made from local materials that are gathered from travels and from where she lives in Oregon. Others turn away from the outer world toward private inner worlds. Still others articulate their refusal to engage high technology with a politics that recognizes the way political and economic power operates to direct and control technology for some over and against others.

Whether you embrace or reject new technologies, you still can deal with significant questions such as who owns and controls access to these technologies and how the development of technology itself is rooted in notions of social and economic progress. Progress, of course, is one of the primary constructs that Euro-American cultures inherited from the Enlightenment, along with reason, truth, and faith in science. While such constructs are avidly questioned within contemporary academic discourse, it is unclear to me how influential the discussion has been within our larger social and intellectual context.

Although I do not want to prescribe or proscribe a particular kind of art, I am convinced that you must consider carefully the nature and impact of the digital and other artistic media that you embrace. To analyze critically the simulated and virtual realities of postmodern culture and to develop a genealogy and critical language for interpreting the screen—these are worthy goals. Neither unmitigated resistance nor blind loyalty to various technologies is appropriate. If you are resistant to or even unaware of the monumental technological changes currently underway, I recommend that you cultivate awareness and overcome your resistance. If you are already totally immersed in and loyal to the new media and our new world(s), I encourage you to develop critical self-consciousness and creative resistance.

Technologies are meant to aid us, as means for giving form to our ideas. You will need to wrestle with this, and especially with the ever-evolving questions regarding materials and the appropriate media for your art in the digital age.

15

THE SCREEN

The screen is changing our relations to the world and to ourselves, as well as to the nature of art. Pay attention to these changes.

Become aware of what the screen does to your body—to your spine, your arms and wrists, your eyes.

At times, your thought will be fragmented; you will be unable to think coherently. This is one of the legacies of the ubiquitous screen, including the television and the computer. Multitasking and continuously interrupted attention are among the facts of life. But recognize the effects of the onslaught of information and media overload for what they are. Breathe. Take a walk.

I was born into the "intermediate generation." I live in the interstice between the book and the screen, between nature—the actual phenomenological world—and virtual reality—the world of simulacra. Mid-sentence, I look up, out the window. A great blue heron stands in the field adjoining the house. Quickly I reach for binoculars. The heron is stalking, delicately lifting one foot after another, neck arched, yellow eyes fixed on something. Then, so quickly I almost miss it, the

heron strikes; its long beak now holds a struggling field mouse. Within moments, the mouse is gone, swallowed. Two mares and a filly trot into view. The heron lifts off. I turn back to the screen.

I also live in the interstice between the sense that the future is secure and the sense that there will not be a future. I have a decidedly apocalyptic orientation, which has everything to do with when I was born and how I perceive the world. The primary image that shaped my adolescent consciousness was The Bomb. I grew up in its shadow and under its threat. The Bomb, for me, is the Damoclean sword that cut history in two—the modern and postmodern are two different worlds. The enormity of the human propensity for evil cannot be glossed over after Hiroshima and Nagasaki. Combined with awareness of the Holocaust, it is difficult to maintain an optimistic perspective on the prospects for human coevolution. Looking at the extraordinary painted scrolls and screens of Iri and Toshi Maruki on the effects of nuclear devastation in Japan, or at the touching paintings and drawings by children in the Terezin concentration camp, makes this insight even more vivid.

To be of this intermediate generation means that certain philosophical questions weigh heavily on me: What does it mean to know? What is the "real," anyway? What does it mean to be a self in cyberspace? What values will define selfhood and community life in the technofuture? What is our moral responsibility to give artistic form to what we sense and see? Cyberia contains many possible virtual worlds. Will they be utopian? Dystopian? Finally, will we even survive as a species? Clearly, no one can answer such questions definitively, but I think about them obsessively.

A vision of life in the future has haunted me for years. A person lives alone, in one room. All the needs of that person

are fulfilled through a machine: food, contact with others, work. Everything is filtered by a complex set of dials, tubes, compartments, and screens that define the parameters of the room. People live underground, or in a great dome, in recycled air and artificially lit spaces.

As I analyze the impact of electronic media in our lives and in the visual arts, I have also grown increasingly concerned about the impact of what Gene Youngblood calls the "broadcast," the broadly cast media net that defines consumer culture and transnational nonresponsive capitalism. My reading has moved in ever-broadening circles, and twice I encountered references to E. M. Forster's short story, "The Machine Stops," that made me want to read it. There, in terse prose, was the description of future life I had visualized for so long. Written in 1909, and published in 1928 in a collection of stories titled *The Eternal Moment*, this was Forster's only attempt at science fiction. I finally remembered that I read the story during my first year of college. At that time, I was more consciously impressed by his idea that our choices are guided by the memory of birth and the expectation of death. Rereading it now, Forster's vision of reality and that future world chills me.

Luckily, those of us living at the outset of the twenty-first century are not yet faced with the dire circumstances described in his apocalyptic narrative. In the midst of a revolution in the electronic technologies that mediate our experience of ourselves and of the world, we still hold an optimistic faith in their salvific power. Or, I should say, *some people* still hold such an optimistic faith. I am skeptical.

This does not mean that I oppose new technologies, reject change, or think that our future salvation lies in returning to a glorious romanticized past when life was not so mediated by machines. But I do seek to foster, in myself and in my stu-

dents, a "resistant embrace" of the screen in general, of television and the computer in particular. Just what does this mean?

A "resistant embrace" might be considered an oxymoron, but hopefully the internal contradiction of the phrase points toward a particular kind of self-reflectiveness. When I simultaneously reach out to embrace and draw back from another person, I cannot help but wonder about these opposing impulses. Reach out! Stop! Hold back! What is going on? What is the nature of this response? Such questioning is appropriate in the face of rapid technological change.

I already have modest skills with the computer. I can design web pages, conduct research on the internet, and teach using digital resources and technologies. I embrace this technology for its unique contributions to my life as scholar and teacher. But I simultaneously reject its insistent incursion into every aspect of my life. I do not wish to be like the main character in Forster's story, totally dependent upon the machine for communication and everyday interaction within my environment.

Television and computer screens are compelling elements of daily life. For most people and for many artists, they represent a breakthrough into a new realm, the next generation in the evolution of technologies. For many years I held the view that consciousness itself is evolutionary. This perspective, articulated by philosophers such as Teilhard de Chardin and Sri Aurobindo, does not see humans as the teleological end of the evolutionary process. Consciousness, which is present in all forms of matter, will continue to evolve, taking new nonmaterial forms. Certainly there is a world-denying element in this philosophy, but it also offers a way of interpreting the evolutionary process on a grand scale. Now I might decide to reject such a grand metanarrative, but it does offer a comprehensive view of time and history.

In youth, I loved the ethereal qualities of music and the fleeting qualities of performance. Artistically, I have always felt an affinity with conceptualism; my performances and installations since 1979 have consistently moved away from the material and permanent and toward the ephemeral and transitory. Cyberia, from this standpoint, represents but the farthest outpost from which to undertake artistic exploration into virtuality, the immaterial and virtual future. As Michael Heim has noted, the recent invention and ongoing evolution of virtual worlds may be the most significant human development since we learned to control fire. All of our relationships—with other humans, with other forms of life, with the earth itself—are changing, and we can hardly imagine what those changes portend. I am attracted toward this great unknown.

But even as I feel swayed in this direction, even as I see new worlds unfolding before me in the screen's electronic glow, I hear neo-Luddites stamping and shouting, breaking things. Like the British Luddites of the nineteenth century who protested the effects of industrialization, their claims resonate with my basic apocalyptic orientation. All resources will be wrested from the earth and the biosphere. All life will be annihilated. The world will die. The march to Cyberia may seem full of pleasurable entertainments at the moment, but it will end in imprisonment and death. Critics of technology may well be this century's prophets; we would do well to heed their cries.

Digital media are the latest (and certainly not the last) artistic frontier. What we will find there as we travel forward in time and space greatly depends upon our individual and collective wisdom. And wisdom, as we should know by now, is in short supply.

16

HOW DO YOU KNOW?

Use information and data to gain knowledge and wisdom. Do not allow yourself to be seduced by information for its own sake.

What does it mean to know? Is knowing a cognitive process, primarily linked to thinking? Or, is it a visual process, dependent upon thinking about what we see? Or, is knowing intimately linked to sound, to silence and speech, to listening? How is it related to our physical embodiment? These are important questions for artists, because creativity is a receptive process. Normally, we think about creativity as active: The artist does something, makes something, intervenes in the world. But I suggest to you that before creative action, there is watching and listening—an inner reflective attitude—for which you must train yourself.

If we decide that knowing is most affected by what we see and if we use primarily visual metaphors ("I *see* what you mean"), then we encourage the distancing of ourselves from the subject, or object, of knowledge. Distance, physical or visual, removes the possibility that subject and object might interact with each other.

By contrast, metaphors related to voice and sound encourage another kind of knowing. Aural and auditory metaphors encourage intimacy. To say "I hear what you mean" suggests closer proximity. It suggests dialogue, not a solitary gaze turned on an object of knowledge. We thus might speculate that when vision is linked to listening and hearing, we foster deeper powers of perception and intuition. Intuition, in fact, is based in this depth and breadth of perception. Without examining such issues about how you know, I believe that questions about who you are and what values you hold are spurious.

In particular, ask what it means to know when the technologies that produce information and knowledge are transformed. How does *information* differ from *ideas*? What are the differences between *data* or *information*, *knowledge*, and *wisdom*? What is authentic knowing?

Available from a variety of sources and able to be easily manipulated using computers, information is the factual data that surrounds us. Information is organized data. Computers are good at storing, retrieving, and organizing data, but they also support a particular model of empiricist thinking. Rooted in the early modern European philosophy of Francis Bacon, René Descartes, and Galileo, this style of inquiry focuses on data acquisition, and it valorizes rigorous interrogation and control of nature through close observation and experimentation. Although this is but one model of thinking that evolved in the European West among a few elite philosophers and scientists, its consequences are profound. In every sphere of life, our efforts to control the world have had disastrous environmental consequences.

In addition, our society seems to be about the increasingly rapid collection and consumption of enormous stores

of information for its own sake or for entertainment. Unfortunately, as Mark C. Taylor and Esa Saarinen have pointed out, the speed of data access is inversely proportional to the ability to retain and understand what is being collected and consumed. In our era, when metanarratives have lost their potency and truths are multiple, this is the closest we can come to an axiom: As we increase the amount of information, meaning decreases; the more information we have, the less we understand what it means.

Understanding is, however, not the only casualty of speed. Addicted to the speed of images on television and to the speed of data transfer and cut and paste, our nervous systems cannot slow down. We are too fast for reading. We are too fast for relating meaningfully to other human beings, and certainly we are too fast for nature. (Who can really afford the time to watch a heron stalk a field mouse or a mare suckle her filly?) Information leaves us gasping to catch our breath.

Ideas are more complex than information. Ideas evolve through the intricate interplay of direct experience, memory, insight, and engagement with the ideas of others. Ideas help us investigate what things, events, and experiences *mean*. Knowledge and wisdom evolve as we grapple imaginatively with ideas.

From one perspective (perhaps a naive one), we might claim exultantly that because of the new possibilities of interactivity and interactive media, we are in a unique historical moment for wrestling with ideas. Whereas information may stand on its own, ideas and knowledge are always intertextual, dialogic. Interactivity seems to present another avenue not only for understanding how ideas evolve, but also for engaging them actively.

At their best, interactive media present opportunities for the viewer and user to make choices that alter their experience with the material. CD-ROMs and DVDs, for example, offer minimally interactive choices that are analogous to reading from an anthology. Various forms of menu-driven hypermedia such as the world wide web offer more choices among links, but the viewer frequently remains a consumer, not a creator. Such work is not performative. A more compelling definition of interactivity would allow viewers and users to structure their own experiences, to create new meanings. If communication were enhanced through choice, control, and direct feedback, then interactivity would be more likely.

Regardless of the potential strengths of interactivity, you need to ask whether it actually offers the artist or viewer true opportunities for participation in creative processes, or whether it is merely a new highly touted form of consumerism. Television and the computer, despite the fact that they are becoming mildly interactive, are also perhaps the most effective modes of managing attention that have yet been devised. The screen controls less through its visual content—although this is certainly significant—and more through the medium itself. If television and computers have not yet become modes of surveillance, they are already techniques of subjectification and subjection for the new docile body who lives his or her life behind and through the screen. Sedentary antinomadic bodies are easier to control than peripatetic ones; as we sit in front of television and computer monitors, we risk losing our autonomy. We "interact" but do not actively engage.

I am far from complacent about the possibilities for greater attention to ideas over information. In our world,

where everything seems to be simultaneously interconnected and in flux, is it possible that the saturation of the senses with information and data not only cripples, but also actually *cauterizes* the imagination? The image of cauterizing is vivid. Tissue is burned, seared, sealed off. If information saturation cauterizes the imagination, you must pay careful attention to the dangers of data overload and the pleasures of electronic manipulation.

What I have described here are epistemological issues. Epistemology is the most fundamental of philosophical discourses. Knowing is both a cognitive and a carnal process. We know because we are simultaneously mind and body. I have tried to indicate that both knowledge and the process of knowing are changing under the impact of new technologies. As an artist, your responsibility is to attend to this question of how you know what you know.

17

WHO ARE YOU?

Inquire into the nature of reality, be it phenomeno-
logical, actual, or virtual. Be sure to examine the
source of the forces that are shaping your experience.

Have you thought deeply about what it means to be
connected to others, in community? Certainly, creativ-
ity can be a satisfying collaborative process, but here I
am thinking about how and where you live.

What is real? What is the relationship of actual physical re-
ality to virtual worlds? What is the nature of being itself in
virtual space? What is the self and what is it becoming?
How are new technologies reshaping individual and com-
munal identity? What does it mean to be embodied in the
era of bionics, artificial intelligence, and virtual reality?

I am certainly not the first to conclude that contemporary
electronic media challenge our most basic ontological as-
sumptions about the world and the self. Some people, and
some artists, live their lives increasingly online. What happens
to physical phenomena and the physical world, what some of
us still call nature, when greater value, emphasis, and re-
sources are placed on virtual life in cyberspace? Will the

depletion of nonrenewable natural resources; the pollution of the land, sea, and air; the breakdown and increasing violence of urban centers; the accelerating extinction of species; even the contingency and fragility of life itself, be of but fading significance if we anticipate a future in air-conditioned rooms, where all of our interactions are conducted through a screen? Will the external world finally matter at all once we have created new virtual worlds that do not suffer from these kinds of problems?

Moreover, we should ask what happens when the electricity shuts down because of terrorist sabotage or simple overload, as in E. M. Forster's story, "The Machine Stops." These questions, of course, are partly rhetorical; they are meant to affirm that what we value as "the real" has tremendous implications for the quality and sustainability of life.

I, for one, agree with Herbert Read's assertion that only those serving an apprenticeship to nature should be trusted with machines. This conviction may be thoroughly utopian. For how many of us care to take the time and exert the energy to enter such an apprenticeship? Is it not easier to go to the movies, rent videos, and surf and shop on the internet than to go outside, find a quiet place, and contemplate the changing of seasons and the cyclical nature of time? Is it not easier to watch TV than to cultivate a garden?

Think, for a moment, about how these questions relate to time. As Ellen Dissanayake has described, Homo sapiens emerged as a species about 40,000 years ago; 1,600 generations (where twenty-five years equal one generation) have lived on earth since then. About 1,300 generations ago, humans lived as nomadic hunter-gatherers. For three hundred generations, from about 7500 B.C.E., we practiced agriculture in villages. Writing was invented 150 generations ago,

in about 4000 B.C.E. The development of the printing press, which made wider literacy possible, occurred twenty generations ago, in the fifteenth century. For only two generations have we engaged with electronic media, especially the television and computer.

Have you ever thought about time as an ontological category, a factor that shapes who you are in the world? Your conception of time shapes you, as inexorably as your relationship to your body, to members of your family, or beloved others. Willingness to contemplate time can be an antidote to the pervasive speed of daily life. Time is both cyclical and linear. The understanding of time as cyclical is grounded in human sensory experience, in the experience of being an embodied self. Linear progressive time seems to be based on imagination and thought, on the capacity to remember and to fantasize, and hence, on the activities of the mind. For many today, time is teleological, headed toward an apocalyptic end. Life happens in a matrix of time, perceived experientially and understood intellectually.

We live in the small time of everyday life, while the great time of history proceeds before and around us. Art, also, can exist in small or great time, but its greatness or smallness does not depend upon whether a particular artifact has an audience in the decades and centuries that follow. The greatness of art is determined by its aspiration to connect us to the earth, to one another, and to the divine.

I suspect that our pervasive flickering screens will affect all aspects of cognitive, affective, and physical life for generations to follow. We are literally changing the nature of physical existence and reality. How do we develop and maintain a sense of identity when confronted with overwhelming pressures toward conformity and as technology takes over more

of our lives? How do we maintain a sense of agency in both personal and public life, when the media of television and the computer are so pervasive and present us with so many already determined options? This is tremendously important for you to consider as an artist. What is your agency as a person? What can you effectively *do*?

I presently live in the Denver metropolitan area, one of the most rapidly growing cities in the United States. Buildings, both private dwellings and huge corporate office complexes, are under construction all over the region. This is "progress," development for the twenty-first century. I do not mean to imply that I am against such progress per se; in fact, it cannot be halted, given the patterns of expansion and population growth that characterize our time. But, I have felt for some years that perhaps the greatest contribution I could make at this historical moment would be to act as steward of a small parcel of land. To care for a patch of earth and to learn from it. Not to begin by stripping the land bare and starting over, but by observing the seasonal rising and falling of the creek, the flight of birds, and the budding, flowering, and dying of weeds. This has become part of my artistic creativity.

Such processes are real to me; they occur in that sphere called "actual phenomenological reality." This sphere is both mundane and extraordinary, for there are few sights more miraculous than rain falling on a stream illuminated by sunlight or a field of blooming dandelions (once you know that all parts of this plant are either edible or medicinal). Virtual realities afford other pleasures, of course, that perhaps should not be compared to Be-ing in a sensual body. We must remember that, in our time, realities are multiple.

Just as the nature of "reality" is undergoing a shift, so traditional notions of selfhood and community are being

challenged by electronic media. Computers have introduced the notion of "windows," a vivid metaphor for thinking about the self as a multiple system, as Sherry Turkle has noted. The self does not have a center, but exists in different worlds and plays different roles simultaneously. In some cases we could even say that self boundaries are erased. Online networks and video and computer games emphasize this plasticity and permeability, whereas the craze to create home pages on the web reflects the desire to redefine the self. Many of us stake out a new territory on the internet. Turkle's use of a real estate metaphor is apt, for it accurately names the way identity is constructed territorially and within a capitalist consumerist ethos. The self/home page, like a house, has modern decor, different rooms, unique styles, and links to other computers all over the world. From the most optimistic perspective, this model of the flexible self, characterized by open lines of communication among its parts, leads to a growing respect for diversity within the larger cultural milieu. Whether this is actually true remains to be seen, and you will have to judge.

Although the desire for self-regeneration and self-replacement, the desire even to escape the body and present identity altogether, are part of the basic quest for human identity, I must acknowledge that I do not want a cyberbody to replace my physical sensory body. For decades I have been committed to the systematic cultivation of the somatic self through yoga. Systems such as yoga and tai chi are especially efficacious for restoring the integrity of somatic experience in an era of suffering bodies, bodies that may be crippled by their relationships with technologies that blind and bind. From eyestrain and spinal pain to carpal tunnel

syndrome, the computer has had an especially strong impact on our physical lives.

Certainly, selves can exist in isolation. I am reminded of the role of monastic solitude in various religious traditions, where some persons seek isolation for periods of time. But this kind of isolation was and is usually supported by a strong shared community ethos. Most selves, however, do not thrive in isolation. Virtual communities may offer new avenues for understanding identity, where the truly flexible and multiple self is called to new forms of moral interaction. But cyberspace is also, paradoxically, about separation. Our minds are separated from our bodies. We are physically separated from one another. We are, in the end, separated from the nontechnological natural world.

What, then, does it mean to be connected to others? What are the ground rules that apply to these new relationships? Interactions in virtual communities are definitely significant, their consequences much greater than simply meaningless diversion or escape. Unfortunately, such virtual interactions may also satisfy our urge for connection without requiring the hard work of direct confrontation and action with, or on behalf of, others. Commonality of interests may substitute for shared long-term goals.

These, as I mentioned earlier, are ontological issues. Ontology is the study of what Michael Heim calls, in his *Metaphysics of Virtual Reality*, "the relative reality of things," differences between the real and the unreal. As you use the computer, or contemplate engaging with new technologies from the desktop computer to wearable and implanted chips, cultivate self-awareness. Think about who you are. What kind of being are you, and who do you want to become?

18

WHAT DO YOU VALUE?

Articulate your values, for if you do not know your own ethical and moral standpoint, you will always be subject to forces outside your control.

Affirm values that may remain constant throughout your life, values such as integrity, strength, honesty, and sincerity. The idealism of such convictions will be tempered by your actual living, but they will continue to provide a moral compass.

Seek to determine for yourself the right definitions and boundaries for thought and action, but use the collective wisdom of others.

What action is right? To whom are you obligated? How does obligation govern our relationships with others? What is good? How does beauty intersect rightness and truth(s)? What is the role of the ugly? Where do you find or constitute the holy?

In posing such questions, I seek to bring your attention to the ways in which values, both tacit and overt, cut through all attempts to understand the self and the world. Each of us holds a worldview and ethos. Here, I want to

focus attention on the ethos or set of values that shape who we are and how we act. This may be called an axiological framework. Yet, we may also be unaware of what those values actually are, and especially unaware of the dominant values of contemporary society. What kind of axiological analysis will help us understand the world in which we live? What kind of ethical reflection will help you articulate the basis for both informed resistance to and informed engagement with new technologies?

A values-centered analysis of the present should include consideration of concepts such as industrialism, industrial and postindustrial capitalism, globalism, militarism, patriarchy, and anthropocentrism. Kirkpatrick Sale has written eloquently about how such systems evolved and about how they shape us. Besides simply understanding what such concepts mean as they unfold in the world, you need to ask questions about their rightness, obligation, virtue, beauty, ugliness, truth, and holiness.

For instance, to what and to whom does industrial capitalism obligate us? Or, put slightly differently, to what and to whom is postindustrial multinational capitalism obligated? What virtues are implied in the broad categories of globalism and globalization, which are both economic and military strategies? Are they selfish? Altruistic? What truths are affirmed through militarism? Further, how do we measure the relative beauty or ugliness of industrial or infotech centers? From Charles Sheeler to Hilla and Bernd Becher, artists have shown us the stark beauty of industrial forms. But others such as Mel Chin, Betsy Damon, Agnes Denes, and Dominique Mazeaud remind us that industrial and postindustrial processes also produce toxic waste that causes disease and disrupts the flow of life in myriad ways.

Or, consider the example of patriarchy. Patriarchy describes the ubiquitous hierarchy of privilege that operates all over the planet. It refers not only to gender hierarchy, which many would say is the first and most pervasive form of domination and subordination, but also to the ways in which privilege and power are determined by race, ethnicity, class, and other differences. I am perplexed by the paucity of reference to patriarchy in contemporary writing. Have we simply stopped naming patriarchy because it seems impervious to change, or because it is so subtly interwoven into institutions from the family to the corporation?

Within contemporary U.S. culture, patriarchal hierarchy and privilege are maintained through direct violence against women of all races and against men of color, through both subtle and overt reassertion of cultural, gender, and ethnic stereotypes, through backlash against affirmative action initiatives and diversity efforts in many academic and public institutions. While there is a widespread rhetoric of appreciation for diversity, in actuality, oppressions based on difference still prevail. Have the efforts of feminists during the twentieth century been so thoroughly subverted that we no longer can name the system that perpetuates violence and injustice? Or, are we simply in a period of retrenchment that will be followed later by another wave of activist change? Increasing racism, conservatism, and religious fundamentalism make continuing analysis of patriarchal values and ongoing social activism all the more important now. Artists such as Carrie Mae Weems, Glenn Ligon, and Suzanne Lacy have made this struggle a focus for their work.

Anthropocentrism is the ruling principle that governs most of our thought. I mean "our thought" in the most inclusive sense, for every culture in which religious mono-

theism and/or secular humanism play a role is based on anthropocentric doctrine and dogma. Even polytheistic or henotheistic systems such as Hinduism are based on giving the gods and goddesses a human face. Reality is interpreted in terms of human values and experience. "Man" is the measure of all things, as Leonardo da Vinci's *Vitruvian Man* so vividly depicts.

In her performance piece, "filename: FUTURFAX," artist Rachel Rosenthal depicts the world of 2012, where water is scarce, animals and trees extinct or dead, and where life is "dry from virtuality." Rosenthal's text, with its reference to formative modern philosophies of Francis Bacon and John Locke, is a powerful indictment of anthropocentrism.

In *The New Atlantis*, published two years before his death in 1626, Bacon described the technological mastery of nature in what might be called the first science fiction utopia. For Bacon, the greatest human ambition was to establish and extend the power and dominion of the human race over the entire universe. Locke shared Bacon's ambition. As Rosenthal characterized Locke's view: "The negation of nature is the road to happiness." And we, the inheritors of these ideas, have become convinced that we are entitled to everything— all of nature, all life-forms, all of the resources on the planet. Certain that everything should be used for personal gain and to fulfill the desires of those with the most power, we ignore the fragility and finiteness of life. Anthropocentric values lead nowhere, or *NowHere*, to paraphrase the title of a recent book edited by Roger Friedland and Deirdre Boden. Anthropocentrism is opposed to biocentrism, biophilia, and a wider spiritual identification with all of life.

Some writers and critics have begun to use the term *posthuman* to designate profound changes in our values and

experiences. The word was first used by Ihab Hassan in a 1977 essay to acknowledge shifts in human desire and the ways in which desire is represented. More recently, scholars have analyzed the impact of virtual culture on our understanding of embodiment.

Lest you think now that I am totally anti-technology, I also want to acknowledge that there is another perspective. From a positive standpoint (which has been well described by Katherine Hayles) this move away from the liberal modern view of the autonomous rational human self toward the posthuman self presents a new opportunity to understand how our physicality, embodiment, and our *differences* structure identity and experience. Considering ourselves as posthuman holds out the possibility that the pervasive anthropocentrism I have just described might be replaced by something else: not the human as the *sine qua non,* but a view that human life exists in a complex matrix upon which we depend for survival.

Few of us feel intellectually prepared for the challenges of this analysis. To ask demanding questions about how we know, about reality itself, and about our cultural and personal values is not frivolous. And it is not impossible or impractical for you to become an active public intellectual and media philosopher. I believe that this is one of the most significant directions art education and creative work might take. As an artist and writer, I actively claim the roles of media philosopher and prophetic critic, choosing to create in arenas where aesthetic questions are never separated from ethical concerns.

The future will be shaped by understanding, insofar as it is possible, and by what Mark C. Taylor and Esa Saarinen called "interstanding." The term *interstanding* emphasizes

that in the era of information overload, understanding is impossible. We simple cannot get under or behind all of this data. We may, however, stand-between the data that surrounds us in order to perceive, criticize, and synthesize in new ways. To occupy these interstices can help us to look with fresh eyes at the many social changes that are disciplining our bodies for the present and the future.

To you I issue a call, a challenge to face the present and to imagine possible futures. Articulate your values and study the values that shape our cultures. Demonstrate, through your art, what your values are and what our social values might become.

CULTIVATING SPIRIT

19

RELIGION, SPIRITUALITY, AND THE SACRED

We live in a pluralistic world. Study the world's major religions—Taoism, Hinduism, Buddhism, Jainism, Judaism, Islam, and Christianity. Find out what religion means in the daily lives of diverse peoples.

What might it mean to resacralize the world? In a century of resource depletion, environmental degradation, changing patterns of climate and weather, think about this and use your art to give form to your ideas.

We enter a marsh filled with quicksand or begin to slip down a slick icy slope when we talk about religion, spirituality, and the sacred. Each of these terms is contested. Their meanings vary depending upon who is talking. Definitions are always inadequate. However, unless one is a self-proclaimed secular atheist, most people would acknowledge that each word names an important aspect of life. Later I will speak more about my own relationship to the sacred, but let me begin these chapters on cultivating the spirit with

a few definitions. What I have to say here is therefore meant to be inclusive rather than narrow or academic.

Religion and art are sisters. Both are cultural systems, as Clifford Geertz has described. They are communal and learned phenomena; they provide us with vocabularies that shape and are shaped by experience. Both art and religion employ symbols, myths, or stories that operate mostly unconsciously, and that are embedded in rituals, actions, and institutions. They are dependent upon particular contexts or locations, and are therefore situational. Because they share so much, it therefore makes sense for the artist to study religion.

For many people, the word *religion* is synonymous with established religions, their institutions, and traditional values. In the temple, synagogue, mosque, church, or meeting house, the world's religious traditions are lived. Gods are worshiped. Cultural values are inculcated. But it is helpful to remember that the word *religion* is derived from the Latin *religio*, "to fasten or bind together." Religions are thus systems of beliefs and practices that connect us to the world, in particular times and places.

For some, the word conjures up images of war, of institutions settled in their own values to such an extent that people are pitted against one another for decades or even centuries. I do not disagree with this assessment, but I am interested in the word for its radical or root connotations. What connects us to others? What binds us in a family, community, nation, or as one planet? What connects us to nature, to history, and to ourselves? Religions try to do this, however imperfectly.

Spirituality is a fuzzy word that seems to mean a more private experience of the divine, however that is conceived. Brought into common usage in the mid- and late twentieth

century, the term is often distained. But again, I would urge you to consider its root meanings. *Spirituality* is derived from the Latin *spiritus*, "spirit or breath." The breath, like the spirit, is integral to life. Both are incorporeal and ineffable, rather mysterious. We are mind, body, *and* spirit.

The word *sacred* is even more general. To be sacred, a thing, person, or activity must be highly valued by us and it must hold power over us. What do you hold sacred or holy? To what are you devoted? For some, the answer will be easy: money, status, material possessions, recognition, awards, exhibitions, publications. For others, the answer may be more difficult to articulate, for what we hold sacred is usually integrated with our values. Is love sacred? Are our relationships to other persons and animals, or to the earth itself, sacred?

For another view of what these terms mean, I offer you a personal point of reference. In 1983 I had reached a major turning point in my creative life. Artistic work had led me into compelling historical and theoretical waters; reading and study had finally whetted my appetite to learn about the philosophical and theological traditions of the European and American West. In graduate school at Harvard, I found great satisfaction in reading the treatises of Greek and medieval philosophers and theologians, and in trying to understand the intellectual innovations of the European reformations and the Enlightenment. I learned about the history of Christianity, including the uses of and fury about the role of images in worship and culture more generally.

I studied all of the world's religions, fascinated especially by the way Zoroastrian ideas had migrated into Judaism and Christianity. For many years Zarathustra was assumed to have taught during the sixth century B.C.E, along with Buddha, Confucius, Lao-Tzu, and Heraclitus. Based on textual

evidence, scholars have suggested recently that Zarathustra actually lived between 1400 and 1200 B.C.E., somewhere on the steppes of what is now Afghanistan or eastern Iran.

The influences of Zoroastrian beliefs on Greek philosophy, Judaism, and Christianity were pervasive. Thales's belief that "all things are full of gods" reflects the Zoroastrian teaching that the Amesha Spentas are both transcendent and immanent. Anaximander's cosmology of boundless worlds coexisting with ours was similar to the Zoroastrian concept of *karshvars* encircling the earth. Heraclitus's focus on fire, as well as the idea that God was Wisdom, was similar to Zoroastrian beliefs. The biblical passage, II Isaiah 40–48, and Zoroastrian Yasna 44 were probably derived from the same Zoroastrian source, which emphasized one omnipotent creator God not previously present in Hebrew texts. Even the prophecy of the advent of the Messiah may have been derived from the Zoroastrian doctrine of Saoshyant, Savior of the Future. Obviously such characterizations are controversial, but they remain a useful counter to Jewish and Christian fundamentalism.

I suppose that, in the end, it comes down to this: I believe that the world is at risk. The future is at risk. Ecological and environmental catastrophes will continue to fuel a critique of modernity, modernization, postmodernity, and globalization. Ours is a situation of chronic global crises vying for attention. These crises—ranging from ubiquitous contamination of the earth, air, and water by toxic pollutants, destruction of tropical rain forests, extinctions on a massive scale, unpredictable climate change, lack of potable water, overpopulation, the ongoing threat posed by nuclear weapons and nuclear contamination, and biological and chemical terrorism—are well documented. Clearly, change is essential for human and planetary survival.

I feel a keen sense of urgency to speak, write, and create in ways that address such perceptions. In this context, to consider questions of religion, of spirituality, and of what is sacred is one way to pose larger questions about the future and about the ultimate as it is connected to the intimate details of daily life. Making art can be a sacred act. I urge you to ask, in your own way, how it might be possible to resacralize the world, to help make the earth a sacred place again.

20

THE ROLE OF
THE TEACHER

Teachers and mentors can guide you, provide inspiration, and help to shape your vocation as an artist. But ultimately, you must become your own teacher—astute, critical, compassionate.

"When the student is ready, the teacher appears." This proverb, which I first heard in relation to spiritual practice, aptly describes the role of the teacher in creative life as well. The emphasis here is on readiness. Do you want help and guidance? Are you ready to learn what another has to teach? I do not mean to imply that you must have an actual person in your life as a teacher. Nature is a teacher, and solitude itself is a teacher. Books and films can teach us a lot. If you do not want a teacher, or if you like learning from books, or if you are far from the places where people who might aid you are working, or if for some other reason you are unable to find a teacher, do not despair. You may simply find inspiration here for rethinking your relationship with teaching and learning.

For many of us, actual teachers are important. There is no road map for how to develop personal vision, as well as the discipline and commitment needed for the creative life. Teachers are not mandatory, but they can help point the way. In a later chapter, I will talk about adversity and about the challenges of inner work that you will face as an artist. Now I must say more about the role of the teacher, mentor, and guide in the creative process.

One of the finest narratives I know about finding and working with a teacher is in Jack Kornfield's *A Path with Heart*. I urge you to read this if you are wondering about whether you need a teacher. My point here is not to say that you must have a teacher, but to offer reflections about the teacher's role. Finding a teacher is a mysterious process, especially since the old and honorable model of apprenticeship has been largely lost. I have no doubt, however, that if you want a teacher, you will find one.

Teachers come in many shapes and sizes. They have many styles. A teacher may be your guru or spiritual guide, your mentor or friend, a taskmaster or a nurturer. Teachers focus on different aspects of the arts: on the creative process itself, on visual thinking and developing visual literacy, on acquisition of technical skills, on making objects or artifacts, on personal expression or development, and on public achievement. Their styles may be encouraging or didactic, compassionate or harshly demanding, full of tricks, humor, or surprise.

But above all else, a teacher should be responsive and perceptive, able to help you develop compassion toward your own process. The best teachers help to create a space, call it a sacred space, in which you can create.

I believe that it is important to acknowledge and honor our teachers, even to pay homage for what we have been given.

Here I want to talk about three of my teachers, whose styles and teaching are markedly different, but all of whom embody qualities of responsiveness, compassion, and generosity.

One person whose name does not appear frequently in these pages is Margaret R. Miles, teacher, mentor, and friend. In offering considerable detail about the issues raised in her teaching and published writing, I emphasize the fact that a teacher may open arenas of intellectual inquiry with wider implications for how to live.

Under Margaret's tutelage, I studied the history of images within Christianity, Greek and Russian Orthodox icon traditions, as well as theories of the image within European and American cultures. Working within this broad context, she explores five interrelated themes in historical Christianity and in contemporary culture: the body, its representation, and values about embodiment and carnal existence; the representation of women and the way gender issues are expressed in images; the nature of bodily and visual pleasure and delight; the role and function of beauty in human life; and cultivating moral responsibility for what we see and how we live, especially as this relates to valuing difference(s). In dealing with the body, for instance, she addresses issues of representation, the dichotomy between nude and naked bodies, and issues of difference and diversity related to gender, race and ethnicity, class, age, and sexuality. Similarly, her approach to the concept of beauty is complex, as she links it to morality, moral responsibility, and attitudes of care toward others and the earth.

In my view, the intellectual power and persuasiveness of her writing is most clear in the methods and theories she uses for interpreting texts and images. There are at least three ways of describing her methodology, two of which are

explicitly related to how we read, the third to how we analyze what we see. In urging a "hermeneutics of generosity" combined with a "hermeneutics of suspicion," in cultivating a practice she calls "reading for life," and in consistently linking texts and images to their social and historical context, Miles offers three interpretive practices that can be adapted for all texts and images.

Miles consistently highlights the tension between a hermeneutics of generosity and a hermeneutics of suspicion. Interpretation and understanding generally develop through a circular process, a back-and-forth movement between reader and text, between parts of a text and the whole text, between the past and present. They involve awareness of both the presuppositions of the text and its author, as well as the presuppositions of the reader and critic. Interpretation should also take account of the historicity of both text and reader. In traditional textual interpretation, a hermeneutics of generosity would lead to trying to understand critically the meaning of ideas presented in a text, but without particular attention to the author's political commitments, institutional loyalties, or assumptions about gender and other markers of difference. By contrast, a hermeneutics of suspicion would directly address the complex relationship of language use to implicit and explicit power structures or issues of racism, sexism, or gender asymmetry in a text. In all of her work, Miles provides examples of how a hermeneutics of suspicion may be tempered by a hermeneutics of generosity.

Miles developed the idea of reading "for life" in order to describe how we might train habits of attentive listening and critical evaluation that are needed in all dimensions of life. There are a number of characteristics of this practice. We learn to identify the serious, gathering pictures of the world,

including warnings, detailed information, and instruction about how to proceed in our daily lives. We practice (re)imagining the self, learning that each of us has a responsibility in relation to the crises and critical issues of our time. We learn to read generously, trying to hear what the author is trying to say. We acknowledge that being interconnected with all of life requires active moral responsibility, and we begin to understand that reading is practice for living responsibly. We encounter and perceive great beauty, which is connected to generosity of spirit and responsibility. As Miles has written so eloquently in *Reading for Life,* "If perceptions of beauty really do produce spontaneous generosity which, in turn, augment responsibility, it is crucial to know how these effects might be generated and stimulated." *How* we read affects how we live.

Throughout her books and articles, Miles sets forth a complex theory of representation. She urges us to become aware of the messages we receive from images, question images presented in the media, and select and develop our own repertoire of images to aid in visualizing personal and social transformation. In interpreting images, whether historical or contemporary, we need to look at their reception, and not only at the intentions of patrons, commissioners, or artists. Miles acknowledges the power of images to provoke repression, but she also sets forth a nuanced perspective on the productive role of feeling, emotion, and the body in our responses to works of art. Images function most effectively to attract and thereby regulate our desire, and both artists and scholars must be attentive to this process. She has also developed a complex method for exploring differences between devotional image use and contemporary media spectatorship. She remains interested in how the term *image* functions

critically, how we can study the social effects of representation, and how images are manipulated. All images inform. They socialize and attract. Although the meanings of images change dramatically over time, their power over us does not. It therefore behooves us to develop sophisticated methods for interpreting images.

Miles also offers a powerful example of how to proceed in public service and private life, how to reconcile social and institutional responsibility with the creative drive. More than anything else, her writing contains sustained reflection about how to live. What do interdisciplinary commitments *mean* in a life? To paraphrase the title of her 1999 presidential address to the American Academy of Religion, how can we "become answerable for what we see"? Miles has talked and written about diversity for many years, about religious pluralism, and about individual and cultural differences. She urges us to oscillate between acknowledgment of particularity *and* unity, between differentiation from *and* identity with "the other," in whatever guise we encounter otherness. Her writing thus has profound implications for both our public and private lives. Read carefully, it invites us to cultivate within ourselves a generous and responsible spirit that actively enjoys life. Regardless of whether we work as artists or teachers, as scholars or critics, this invitation is a great gift.

Over many years, Margaret has encouraged me to take myself—and my yearning and vision—seriously. Once, listening to my rambling about a range of future possibilities, she urged me to engage in a process of discernment to identify my authentic goals. I mustered the courage to undertake writing this book with her urging at the forefront of my consciousness. For all of this, I am immensely grateful.

Besides stimulating the intellect, teachers can also help us grow into and inhabit our bodies. I met Angela Farmer in late 1975, when I moved to England from the Lindisfarne Association in New York. Planning to travel to India to study at the B. K. S. Iyengar Yoga Institute in Pune, I had written Mr. Iyengar, asking permission to come. He wrote back immediately, urging me to stay in London and work with senior teachers there. And so I met Angela. I have worked with her in a variety of settings in the United States, Canada, England, and Greece.

Over years, the focus of Angela's teaching has moved from technique to the essence of yoga, from the exoteric to the esoteric body. She helped form my understanding of contemplative practice. But she also shaped my ideas about the role of the teacher. Angela talks frequently of how necessary it is to experience and trust one's own somatic reality. This means paying attention to the body, to both sensation and intuition. Through listening to yourself, becoming responsible for your experience, and especially taking care not to harm yourself or others, you will learn not to be dependent upon a teacher. Acquiring this attitude from her, I have come, over time, to rely on my own intuitive sense of inner necessity and direction. Few teachers provide such genuine inspiration to transcend self-imposed limits and to foster greater individual integrity. Angela Farmer is such a teacher.

If Angela was the teacher who showed me how to live more fully in the body, then M. C. Richards can be described as the one who tutored me in the connections of art and life. Mary Caroline Richards's life, published writings, and artistic work continue to provide me with a sense of possibility and a model for how to live. Her example and hortatory verbal style had a great impact on me. Her intellectual ancestors,

from Antonin Artaud to Owen Barfield and Rudolf Steiner, also influenced my intellectual and spiritual development.

For example, at her urging I began to read the anthroposophical writings of Rudolf Steiner, beginning with his *Knowledge of Higher Worlds and Its Attainment* (retranslated and published in 1994 as *How to Know Higher Worlds*). I read this book at a particularly timely moment in my twenties, when I was searching for an opening into the spiritual world. Steiner's suggestion, that preparation for such knowledge must begin with observation of living and dying processes, was absolutely formative. One day I found a beautifully preserved dead butterfly—a swallowtail—and drew it meticulously. Another day I found a dead goldfinch, and did the same. I had always loved the physical world, but suddenly it became a teacher. Steiner's written instruction on how to cultivate one's perceptual powers and the life of feeling and devotion has thus influenced my artistic and spiritual life. Subsequently, reading *Toward Wholeness*, M. C. Richards's book on Waldorf education, learning about biodynamic gardening, joining her at a Waldorf teacher training course, and visiting her many times until her death in 1999, I developed great respect for Rudolf Steiner's influence in several spheres.

In 1973, at a particularly difficult juncture in my young adult life, M. C. said that she would be my "spiritual mother." I thought of her in this way for several decades. Over the years, we visited in many settings and talked about both mundane affairs and great mysteries. Intellectually, her ideas shaped my thinking: the metaphors of pottery, of centering and the transforming fire; the relationship of language to feeling, to the body, and to artistic form; and the profound dialogue that characterizes true pedagogy. In more recent years, her reflections on aging, homelessness, and living

the last phase of life moved me. Spiritually, she embodied a way of being in the world that takes account of the shifting and flowing of things. As my spiritual mother, she was both inspiration and compass.

M. C. died in September 1999 at age eighty-three, and she was cremated after a three-day vigil and memorial service. She had lived since 1984 at an agricultural community that is part of the network of Camphill Villages based on Steiner's ideas. She taught me to listen to my inner voices, to have courage in the face of adversity, to affirm the artistic possibilities of language, and—more than anything else—to find and follow my own true vocation.

Now, looking back over nearly three decades of knowing her, I realize that I often hesitated to tell her what troubled me or to celebrate my successes. On the day of her memorial service, I felt keen regret that I did not share more. But perhaps regret is self-indulgent. I loved her. Born into a family where emotional and physical distance were the norm, I did the best I could to express my love.

The primary lesson here is "communicate with your teachers." Initiate dialogue, discuss what you really think and feel. Be authentic in expressing yourself. As an artist, you will be shaped by many experiences and people. Let your intellectual, physical, and spiritual lives be affected by your teachers and mentors. Choosing them carefully, and responding attentively to those who come your way, can have a huge impact upon your identity as an artist.

21

CONTEMPLATIVE PRACTICE

Always return to the practices of mindful attention, to observing the world as it presents itself. Discipline yourself rather than being disciplined by others. Establish a daily, or at least a five-day-a-week, contemplative practice.

If you have not done so already, initiate basic practices of caring for yourself. These can be as simple as paying attention to your diet, to your sleep patterns, and exercise. Explore the healing arts, from massage to alternative medicine. It is vital that you restore and heal your body.

Treat your art as a form of spiritual practice, which means centering yourself, focusing your attention, and engaging regularly with mindfulness.

Two aspects of contemplative practice are worthy of your consideration: actually establishing a regular practice of mindfulness, and treating your art itself as spiritual practice. If you already have an established practice, or this idea is familiar to you, I recommend skimming through what follows. Build on what you already know, the practices that you have

been taught and to which you feel connected. However, you might well ask what I mean by this phrase, "contemplative practice," and if so, read on.

There are many forms of contemplative practice: forms of meditation such as prayer and mindful sitting, singing and chanting; movement and mindful actions such as yoga and tai chi, liturgical dancing and walking; and focused experience in nature.

Contemplative practice will be beneficial for you in numerous ways, as it has the ability to create a variety of changes. It will foster calm and reduce stress, increase awareness of the present, enable you to better question and explore your assumptions about yourself and your art, help you to understand and to know viscerally the interconnectedness of life, and deepen your sense of compassion and equanimity.

A brief history of contemplative practice and its relationship to traditional education is certainly beyond the scope of what I can offer here. But it is notable that a split between contemplative traditions and academic study occurred in European traditions in the twelfth and thirteenth centuries, as universities consolidated their curricula separate from monastic and cathedral schools. However, in parts of Asia—in Buddhist Tibet, for example—such a separation did not occur. There, religious education, instruction in meditation, and academic study were all part of one's overall education. My own educational and artistic ideals see spiritual development as an important component of education, alongside acquisition of knowledge, conceptual and critical thinking, and technical skills.

Most of us need a period of exploration in order to ascertain what we might do. Explore the resources that are available to you. But whatever you choose to do, integrate your

practice into daily life. Develop your own methods of account-ability, which might include talking with a friend or keeping a journal, or working with a teacher on a regular basis.

Even if your art is not figurative or representational, contemplative practice will help you develop the ability to observe and to attend to your senses. Such practices are directly related to developing self-discipline, which will have a profound affect on your art practice. The ability to observe, to stay in the present, and to pay attention to passing sense impressions is essential for an artist. Contemplative practice is also related deeply to other practices of self-care, and it can be a vital part of healing and restoring health to the body.

Especially given the information overload and speed of contemporary life, contemplation helps to quiet the inner and outer chatter so that you may listen to yourself and increase your ability to visualize and imagine. In particular, if speed cauterizes the imagination, as I argued earlier, then slowing down is an effective means for cultivating imagination.

What kind of faculty is the imagination? Philosophers from Plato and Aristotle have studied, analyzed, and conjectured about how the imagination functions and why it is important. It is an active psychological and cognitive process, a mediator between sense perception, thought, and memory. Imagination might be visualized as the mediator between outer sight and inner vision. For the artist, an active imagination is essential, and contemplative practice can help make it more active.

My own contemplative practice presently is centered in yoga and breathing, as well as mindfulness meditation. Following my first yoga class in 1969 in Eugene, Oregon, I began serious yoga practice in 1975 at the Lindisfarne Association in New York. I was also introduced to Soto Zen practice

at this time and have intermittently practiced zazen. Sufi dancing and zikr were offered, and I also studied Kabbala and other esoteric traditions. I attended the San Francisco Yoga Institute in 1979 and obtained certification to teach yoga. For some years I taught both public and private courses in the Pacific Northwest and Massachusetts. Presently I am not teaching classes, but maintain my daily practice.

What have I learned, you might ask, through these years? I learned to pay attention to deep inner experience—the obvious physical sensations, as in the spine or pelvis or upper torso, and the more subtle feelings of openness, vulnerability, and surrender that arise as one breathes life into dull or once dead areas of the body. I learned to concentrate awareness in the *hara*, the belly, to awaken dormant energy, to discover the locus and source of the vital life force. Like the sound of a Tibetan bowl gong, certain images that I first heard from Angela Farmer resonate in me. The sternum flies, or opens like a flower toward the sun, or *is* the sun. The breath is like a wave of the ocean, each inhalation a moment of quiet, each exhalation an extension, release, surrender. The body is like a tree with roots, trunk, branches, leaves, and flowers. We stand, planted firmly, gently moving in the breeze. Or, the spine is like the tail of a kite, where light and space inhabit the vertebral interstices. We are at once trees and Greek or Egyptian statues, majestic in our utter presentness. Each of us is an *axis mundi*, the central pole that connects the underworld, earth, and heavens.

Preparing for the *asana* is like cleaning one's house before a guest arrives, or like a surfer awaiting the wave. If the preparation is done, if the body is quiet, then perhaps and suddenly a release takes place, and one can ride the release like a wave. You just have to wait, letting go of all your

ideas about the body. Finally, through the process of becoming aware, undoing tightness, and releasing tension, I have gained a sense of autonomy. These insights have affected every aspect of my creative life.

The process of individual transformation is a lifelong journey, but you can begin now.

In addition to undertaking contemplative practice, have you ever considered that art-making itself might be a form of spiritual practice, with both inner and outer dimensions? On the one hand, traditional artists engaged in practices of inner purification through their work, cultivating values such as attentiveness, detachment, patience, humility, and silence. On the other hand, the artist was giving form to religious and moral teachings. As such, the work expressed a calling—*a vocation*—to make spiritual teachings available to various publics.

For artists already interested in or committed to a particular spirituality or practice such as Christian prayer; Hindu, Buddhist, or Taoist yoga; or Buddhist meditation, this interpretation of art as spiritual practice might be easily incorporated into a working process. But many secular artists actively repudiate any form of organized religion.

Nevertheless, this inner dimension of art is readily accessible to all artists. What if, as a regular part of studio education, artists were taught how to be silent, to meditate, and to learn techniques of visualization? Stillness and silence allow you to experience life at a different level, to listen not only to yourself, but also to the many other audible (and inaudible) voices that surround you. Values of attentiveness, acceptance, and contentment can be fostered through such practice as well.

One artist whose life work may be interpreted in this way is Remedios Varo. Spanish by origin, Varo studied during the

1920s with Salvador Dalí and other surrealist artists at the Academia de San Fernando in Madrid, but lived most of her adult life in Mexico. She died suddenly in 1963. Unlike others of the surrealists, however, Varo was unusual for her explicit and persistent interest in religion, but not in the Catholicism of her youth. In trying to resolve broadly religious questions, Varo turned to the esoteric and hermetic traditions. When she died, her library contained books by Maurice Nicoll, P. D. Ouspensky, George Gurdjieff, Freud's and Jung's complete works, Madame Blavatsky, D. T. Suzuki, Alexandra David-Neel, Paramahansa Yogananda, and Simone Weil, among others. Intellectually, her paintings were influenced by alchemy; Pythagorean ideas; numerology and sacred geometry; and Platonic philosophy. But they also may be interpreted as contemplative in origin, for they express a deep spiritual longing.

Varo's painting *Creation of the Birds* (1957) is an image that demonstrates the interconnectedness of all things. An owl-like figure with a kind, heart-shaped face is rendered exquisitely with fine brush strokes. This figure sits at a small table, wearing a lyrelike instrument with three strings and holding a triangular prism in one hand, which refracts the light from a distant star/moon, while, with the other, s/he simultaneously draws birds that come to life. More ethereal energy is transformed in two egg-shaped vessels and flows from the tubes as the three primary colors. A small bird pecks at seeds on the floor. The floor is composed of an imprecise checkerboard; the legs of the main figure are aligned to the central axis. It is night. Two "communicating vessels" inhabit the back corner, while a strange old-fashioned box (perhaps another alchemical vessel) rests against the other wall. In surrealist thought, these communicating vessels were metaphors

for the interaction of sleeping and waking consciousness, of inner vision and external reality. They vividly demonstrate that a link between modes of consciousness is possible and also might be interpreted as an image for love. *Creation of the Birds* is a thoroughly magical image, depicting the union of self and nature as a source of energy and creativity.

In Varo's *Ascension to Mount Analogue* (1960), a lone figure begins the arduous ascent of a mountain. She, or he (for the gender is ambiguous), floats on a small raft, holding parts of a loose garment as the sail and spiraling toward the mountain peak. In Rene Daumal's short novel, titled *Mount Analogue*, the goal of the quest is to find peradems, a golden alpine flower that could be picked only if one did not want it, and that would bring spiritual purification and inner peace. In Varo's essentially mysterious painting, I believe that the figure stands for spiritual purification, personal transformation, and wholeness. The spiritual journey is difficult, but the path is visible.

The sense of a "call," a personal journey toward wholeness and enlightenment, is clearly depicted in Varo's *The Call* (1961). The central figure, luminous with radiating filaments of light, wearing and carrying alchemical vessels, her hand in a gesture similar to a Buddhist mudra, leaves behind other half-awake, half-conscious, people. She is initiated into the process of spiritual becoming, although how or why is unclear. Like the androgynous figures in Varo's other paintings, she also leaves behind the state of sleep, a state that mystics such as Gurdjieff thought was our normal human condition. Paintings such as *Creation of the Birds, The Call,* and *Ascension to Mount Analogue* may be interpreted as extended meditations on the process of creating and transforming the self.

If this idea of art as a spiritual practice appeals to you, I urge you to read Nancy Azara's book, *Spirit Taking Form, Making a Spiritual Practice of Making Art.* It does not matter if you have ever studied art before, or if you are an accomplished artist. Azara's exercises and meditations will guide you adeptly into this arena.

To make art that is inflected and influenced by contemplative experience during yoga, meditation, or prayer, and to make art that is itself a form of spiritual practice: These might be seen as two sides of a coin. Some of the most profound examples of such art come from experiencing sacred space and engaging with particular places.

22

SACRED SPACE

All people, in all times, have created sacred space. Now it is time to treat the earth itself as sacred, and to observe with awe the ineffable beauty and mystery of the world.

Why are we humans drawn toward creating rituals, special places, and sacred spaces? This is a big question, and one that I will try to answer personally. I have been creating such spaces for nearly twenty-five years, first in galleries, and more recently where I live. This chapter describes two examples of my attempts to create sacred space and ends with a longer narrative about the way one particular place affected me. I hope that these descriptions move you to consider the ways in which your own work might grapple with sacred space, and with its place in your world.

I have consistently felt compelled to work in ways that minimally impact the earth and our precious resources. Related to experiments with writing and drawing, I created a series of installations and performances that dealt with themes of ritual initiation, death, environmental destruction, and regeneration, all aspects of both inner and outer life.

The research, writing, and planning for these installations and performances began with two simple questions, both of which I urge you to consider as they apply to your own creative process. First, what matters enough to warrant sustained attention, as well as public presentation? Second, how is it possible to create using found or recycled materials and the intrinsic qualities of bodily gesture, movement, and sound? In answering these questions, two paths converged in my creative process: an ideological commitment to avoid the traps associated with producing art to meet consumer demands, and the simultaneous pleasure of learning through years of contemplative practice that the human body and voice are perhaps the most direct means for creative expression.

In the 1979 *Gaea* installation, for example, I expressed concern about the extinction of species, depletion of natural resources, pollution of the environment, and overpopulation. In preparing to install the piece, I drove across the state of Oregon, collecting stones, earth, sand, and sticks from various sites; then, I spent several days arranging these materials in a gallery in Corvallis to form a figure on the floor.

After I had completed the installation itself, I posted a word-tree image on the wall:

> The earth is precious, a sacrosanct body on which we live. She is a goddess, and this work is named after the Greek goddess, Gaea, who is the sure foundation of all that is, the first being born of chaos and from whom all else evolved. Here Gaea is composed of naturally occurring materials, collected from my regional environment, and replaceable in that environment. The *prima materia* is transformed by arranging rather than by unalterable firing. Increasingly I choose to work in ways that sidestep our habitual cycles of production and consumption, ways that resist the commod-

ity market, that neither pollute nor use non-renewable resources, that loosen the boundaries and constrictions of Mind, and that express an attitude of reverence for the earth and coexistence with all sentient beings. Still, my grasping mind asks, *but what is art? My spirit gives an elusive answer: This body is a vision. I am the earth as the sea is my blood. I am clay, sand, stone, stick, string, cinder, and seed.*

In two *Temenos* installations during 1980 and 1981, I sought to create spaces for contemplation, using mostly found materials as I had in *Gaea*—sand, stones, sticks, clay, and cloth. The Greek word *temenos* means "sacred precinct," a share of land apportioned to the god or goddess and a center of worship. Many cultures have defined sacred space using enclosures, temples, and gardens. In these gallery installations, I wanted to evoke the presence of a temple where the world might be resanctified. "As I witness the literal destruction of life on the planet," the gallery materials proclaimed, "a sense of urgency arises. I seek to reestablish a sense of connection with the body/earth, and to rediscover the holy in all spaces and living beings."

In retrospect, I view these installations as courageous, but partial. There are, of course, limitations to such gallery work. Although this work might provoke reflection, it does not actually create change in a place. Nor does it help us to witness the sacredness of particular places.

A visit to Samothrace, Greece, was an experience of the magic, mystery, and sacredness of place. I stayed in the home of Vassili and Vassiliki, in the town of Loutra. A few days after a visit to the site of the ancient mysteries, which I described earlier, Vassili took me to the top of Mount Phengari. He woke me at 5:30 A.M., and I dressed quickly to go. When I saw his mule packed to go too, I felt dismayed, thinking

that he had decided I would not be able to walk. Only later, in our peculiar combination of mime, German, and Greek, did he tell me that his right knee bothered him and that we would take turns riding *mulari*. When we reached the edge of town, Vassili put me on *mulari*. After initial consternation I was grateful, for the way was rocky and difficult. On the first steep part of the ascent, he rode. Then, as we approached tree line, we tied *mulari* to one of the few remaining oak trees and began the steeper ascent over *petra*, "rock." We came eventually to the last tree, a majestic old oak, with its huge trunk split open so wide that I could have crawled inside. Scrambling over the bare stone was treacherous and demanded full attention. Forced to concentrate, I was reminded of the Zen walking practice, *kinhin*.

Finally we stopped for breakfast about 9:15 A.M. I had had nothing to eat or drink and was both hungry and thirsty. After our meal of bread, cucumber, Vassiliki's home-cured olives, almonds, and eggs from the chickens she was always yelling and throwing stones at, we headed for the top. I felt gloriously happy as we climbed, hand over hand, looking for toeholds. At last we came to the first of two markers. The airplane from Alexandropolis flew over and we waved; nearby fighter jets made ominous ear-shattering sounds with their target practice. But mostly there were only the sounds of goat and sheep bells and the ever-present wind.

The climb to the second marker was even more arduous. At the highest point we ate peaches and sat in silence. Sky and sea were exactly the same hue of blue, the land a lighter gray blue. I was stunned. Inexplicably, the sheep were silent for a time, and as we rose from sitting, a hawk cried and circled below us. I felt there, as I had at the Paleopolis site, that we live in a magical world of omens, totem animals,

and stones that emanate spirit. I could have sat on that mountaintop, motionless, for an eternity.

Our descent was more difficult than the climb. My knees and thighs quivered; I thought they would buckle as I began to stumble and slip. This was a different kind of trial, one of determination to continue in adversity. Like many experiences of the day, this too seemed a metaphor for all of life. We stopped in a *temenos*, a grove of ten ancient oaks. Vassili wandered off alone. I sat, feeling the sacredness of place, then rose to stand amidst the *petra*. Once there had been a stone building; remains of the wall were scattered around. When Vassili returned, we continued our descent, untying *mulari*, who eagerly led the way. When we reached the *droma*, the road that was so stony and slippery, even *mulari* tripped, and we burst into hilarious laughter.

Closer to town we stopped at a stream to drink and refresh ourselves. It was a curious moment, for although we had been respectfully distant from each other during the day, we had also shared an intimacy that was clearly over. When we walked into the village square, Vassiliki was there, waiting. She spoke to me in Greek and I responded in English. She pinched my cheek; I went off to bathe. At the house, Vassili was taking the saddle off *mulari*; all I could say was "thank you."

Vassili had touched me profoundly, from his first appearance one evening, when he pulled a green pepper out of his pocket and grinned, to his few tears in the garden as we said a final good-bye. "*A deo,*" I said to him, as he had said to the mountain when we began our descent. "To God." Vassili showed me the holiness of the island in such a matter-of-fact way. Here the ancient oak, here the sacred grove where once a stone building stood, here Phengari, here the crescent

moon, *phengari* too. The beans he planted spiraled up twisted madrone boughs, mini trees of life. There was *mulari*, to whom he spoke with such gentleness. Tree, rock, mountain, moon, bean, mule, a man: all living manifestations of Being, defined by relations that can only be called divine.

How can one possibly represent such experiences of sacred space and experience of the sacred? Verbal language certainly pales, photographs are never adequate, and visual images only carry a semblance of their power. Nevertheless, I spent many hours drawing and painting watercolors of the sea and the mountains. My visit to Samothrace was an allegory: an experience of presence, of the numinous, of mystery and awe in the face of the ineffable, an experience of relation and of love.

23

ART AND AGRICULTURE

Become a home-comer, rather than a home-owner. Come home to a place that will nurture your art and your psyche.

To speak of life and death can be a cliché. However, to observe carefully the processes of living and dying as they occur in your immediate environment is a profound spiritual practice. It will affect every aspect of your Be-ing.

In *Opening Our Moral Eye*, M. C. Richards wrote passionately about "the renewal of art through agriculture." She claimed that art is a form of spiritual perception, which is developed through imagination. How do we enhance our powers of imagination? Through carefully observing how all things live and how they die. Time can be experienced through color, especially the changes of color associated with different times of day and year. Both farmer and artist watch the sky and learn to read it, through clouds, light, shadow, and stars. Tending plants and observing the world, we learn meditative attention. We develop both outer sight and inner vision.

Related to these ideas, Wes Jackson suggests that now "it is time for a new breed of artists to enter front and center, for the point of art, after all, is to connect." Such artists will be "homecomers," persons who choose "not necessarily to go home but to go someplace and dig in and begin the long search and experiment to become native."

I am engaged in this process that Richards and Jackson describe, and I urge you to consider how these ideas might be relevant to you.

I live in a place that I want to study and to know. I seek knowledge of what grows and lives here and of how the elements change over the course of days, months, and years—knowledge that comes from observing and listening to the world. This is gnosis. If we can more thoroughly understand our relationship to where we are, to the time and place—the chronotope—we inhabit, then we may be able to live-ourselves-into a new relationship to the future. As many of us spend our lives increasingly online, some of us must nurture connections to the earth and remember the phenomenological world.

A few years ago I began to write Greek and Latin words in stone: *temenos, vocatio, amor fati.* "Sacred precinct," "calling," "love of fate." This practice is part of "[THIS] Place," a project to define the *topos,* or "place" of art. The curious way that I bracket the title of the project is meant to emphasize that I live and work in *this* place, not that place or some other place.

Russian philosopher Sergei Bulgakov's vivid interpretation of the artistic possibilities and power of language has given me a way to think about this work. Though he wrote *Filosofiia imeni* (Philosophy of the Word) in 1919, it was not published until 1953, after he died. Bulgakov's long essay,

which has not yet been translated into English, includes chapters on speech and the word, on language and thought, and on the name of God. Bulgakov claimed that "The word is the world, for it [the word] has its own ideas and speaks, but the world is not the word, or more exactly, it is not only the word, because it also has metalogical wordless existence. The word is cosmic in its essence, for it belongs not only to the consciousness where it flares up, but to being itself" (my translation).

As a woman who writes in stone, I feel that such ideas have tremendous validity. It seems as though I name the world with each groove left by a steel chisel, calling forth the meaning of which words speak. Yet, this is an egocentric and anthropocentric point of view. I must remember that a stone word lives an independent life; it has a strange animate presence. Like the inscriptions at the Samothracian sanctuary, such stones will remain, declaring themselves, for a very long time. Perhaps the word is not the world, as Bulgakov claimed, but his insistence on the presence and power of language should make us think again about the pulsing and blaring of words on our screens.

Earlier, I noted that as a young adult I was inspired by the contemplative architecture and gardens of India and Japan—from the Stupa at Sanchi and the Khajuraho temple complex to the Zen gardens at Ryoanji. My commitment to creating aesthetic experience rather than art products was further strengthened not only by creating installations and performances during the 1970s and 1980s, but also by years of writing art reviews and witnessing the art world close-up.

Recently, my thinking has also been greatly influenced by reading about architecture and landscape, from Christopher Alexander to J. B. Jackson and Wes Jackson, and by learning

more about what other artists are doing, as Lucy Lippard has described in *The Lure of the Local*. For instance, I renewed my acquaintance with the work of Ian Hamilton Finlay, whose art I first encountered in the early 1970s. Since the 1960s he and Sue Finlay have developed a fourteen-acre site called Stonypath at their home outside of Edinburgh, Scotland. Also called Little Sparta, this large garden is a kind of earthwork on a human scale. The Finlays worked with masons, stone carvers, and other artists and designers to create a complex environment with paths, plantings, and sculpture.

In 1982, Agnes Denes began work on a site near Battery Park in lower Manhattan, close to the former World Trade Center. She called the project *Wheatfield, Battery City Park: A Confrontation*. There, she cleared debris from four acres that had been used as a landfill, spread an inch of topsoil, and planted two acres of wheat. For four months she cared for the field until it was fully grown. In August she harvested 1,000 pounds of grain and fed it to horses from the New York City Police Department.

Between 1992 and 1996, Denes undertook a much larger project called *Tree Mountain—A Living Time Capsule*. In Ylorski, Finland, Denes built a hill on top of gravel pits, approximately 420 by 270 by 28 meters. She shaped the hill as an ellipse, and then invited 10,000 people from all over the world to plant trees there. Each tree bears the name of the person who planted it and is designed to bear the names of that person's ancestors for four hundred years. Her intention is both to transform a blighted landscape into an abundant forest, and to engage a diverse community in a massive collaborative project. Works such as *Wheatfield* and *Tree Mountain* are examples of what Denes calls "philosophy in the land." These monumental eco-projects are conceptualized

and designed at the intersection of philosophy, mathematics, science, and community.

Mel Chin's project *Revival Field* is a powerful example of another kind of eco-project. In 1990, at the Pig's Eye landfill in St. Paul, Minnesota, artist Chin and scientist Rufus L. Chaney began a project to reclaim ravaged land. *Revival Field* was a long-term project that addressed environmental, political, and social issues. Their goal was to detoxify a sixty-square-foot area in the landfill by doing "green remediation," using plants knows as hyperaccumulators that, as they grow, extract heavy metals such as zinc and cadmium from the soil. After it was originally planted, this "garden" was cared for by the St. Paul Maintenance Department; and in fall of 1991, the plants were harvested, dried, ashed, and analyzed under controlled conditions by Dr. Chaney.

Chin and his collaborators hope that eventually land restoration projects such as *Revival Field* will help with the cost of healing toxic landfills. For the tenth anniversary of this first project, Chin initiated a similar collaboration with the Institute of Plant Nutrition at the University of Hohenheim in Stuttgart, Germany.

I am certainly not alone with my questions and commitments. Each of these artists caused me to ponder and to affirm my aesthetic goals for *[THIS] Place*. On one level, *[THIS] Place* is simply where I live: a one-acre polygon, bordered on its longest side by the James Creek. The house is located on the south side of the James Canyon, near three other structures—a stone sanctuary, small office, and studio. A spring becomes a rivulet along the upper bench, where I cultivate nettles. Willow trees abound. Over the past few years, I have laid stones around the circumference. Daily I

circumambulate the site and rake the paths, entering into relationship with this *temenos*. I grow edible and medicinal herbs: garlic and greens, pennyroyal and purple coneflower, sage and raspberry, motherwort and Saint Joan's wort, lemon balm and chocolate mint, yerba mansa and rehmannia, horseradish and valerian. Sitting on various perches, I watch the light play across trees with their branches stretching one hundred feet into the sky. And the sky! Cerulean, azure, pristine. In cities from San Francisco to Boston, from Vladivostok to Lucknow, this blue appears faded, the air varying shades of brown.

On another level, however, *[THIS] Place* is a creative project about contemplative space and about belonging and community. I am exploring the vagaries of living at a particular time and place, this *chronos* and *topos*, cultivating both my powers of perception and engaging the land, its history, and its present state. The Southern Arapaho tribes spent summers in this canyon before the Sand Creek Massacre in 1864. Later in the nineteenth century, the area was a major center for mining gold, silver, and other precious metals. The legacies of that activity currently include reclamation of wetlands and cleanup of toxic mines. The fact that *[THIS] Place* has also had its own history is pertinent to how I think about and interact with it.

The paths I create around *[THIS] Place,* the trees whose trunks resemble bodies emerging from the earth, the water that overflows its banks or flows submerged under ice: All function as metaphors for other aspects of life. Everything happens not only within a nexus of dialogues and relationships, but also no artifact of culture ever exists outside of particular moments in historical time and place.

René Dubos suggested that people will be drawn to landscapes that include three particular elements: a secure and comfortable place or refuge; a prospect or vantage point that offers a broad view; and water, for the presence of water means survival and life. As I engage *[THIS] Place,* its present and past, and as I shape and reshape it for the future, Dubos's ideas also resonate with me.

Many artists are searching for a compelling interpretation of their vocation. Many seek justification that places art in a larger context. Within the highly commodified gallery-museum system, only a few gain renown or earn enough money to pay the rent. What, then, should be the place of the creative arts? I believe that the place of art is in daily life, and I act out that conviction here, now, in *[THIS] Place.*

Art and agriculture are unusual partners, unless one looks deeply at process. I suggest that you look around, where you live. Observe a farm, if there is one close by. Watch the changing of the seasons, planting and harvesting, watering, weeding, and tending. Observe how there is a period of dormancy, how the earth must rest. Consider how this cycling of the seasons and of human activity might be relevant to your own creative processes. And if you live in a thoroughly urban setting, you can still observe the sky, the weather, how and when flowers grow. Or better yet, plant some seeds yourself. The development of your own inner vision will be greatly enhanced by observing what your outer sight can tell you.

24

FIRE AND ADVERSITY

Cultivate your imagination. Imagination is a complex mental process that combines sense perception, visual memory, intuition, and cognition. Without the fire of imagination, most of us would die. Or, to paraphrase William James, without imagination, a people perish.

Prepare for adversity and develop a range of skills that will help you face the difficult when it comes. These skills might include learning to observe and witness yourself, to name experience, stay with it, and seek help from others. Neither fighting nor fleeing are effective strategies, for they will only tire you.

Three boys throw something into an old car that sits on a street in front of a building. A small flame begins to burn. Carefully noting the boys' clothes so that I can identify them, I run after them, nearly catching one, but they get away. Then, the car is engulfed in flames and I run back, yelling "FIRE, FIRE!" I hope someone has by now called the fire department. I run to stand behind a wall because I sense that an explosion is imminent. When next I peer out, I see that the fire has destroyed everything.

This dream reminds me that when I was a young child, our neighbor's house caught fire one night. I stood transfixed as the firefighters turned the flames to smoke and the house was saved. Fire consumes and destroys. Fire is a primordial metaphor for all kinds of adversity. Yet I have seen, at Mount St. Helens and in Yellowstone National Park, that fire prepares the way for new growth. How might we understand the meaning and power of fire, and in particular, how might reflection about fire help us deal with difficulty and adversity?

I first started thinking seriously about fire as a young student. At the urging of my ceramics professor, I watched a candle burn, until I comprehended the colors of heat. Simultaneously I learned that this is an ancient method of training the mind for meditation. Wanting to understand the differences between conduction, convection, and radiation, I looked up the treatises of the English scientist Michael Faraday (1791–1867) concerning how energy is transformed.

In the days before computerized kilns, I also learned to dance with that magic flame. Like the mythological Greek goddess Hestia, I tended the fire, adjusting the burners as the interior chamber temperature rose from dull orange to white heat. I made a series of vestal virgins. But my personal enchantment with fire is only a small part of this narrative.

In folklore, mythology, and religion, stories of the origins and power of fire are ubiquitous. The ancient Indo-Iranian fire god Agni was a wise emissary between the gods and humans. Zoroastrians worshiped, and still worship, fire as the unseen vital force that pervades all creation. Greek and Roman myths gave special place to female deities and actual women as keepers of the flame. In Japanese Shugendo traditions, which combine practices from folk religion and esoteric

Buddhism, fire rituals are used in healing. In Judaism and
Christianity, fire is associated with the holiness and ineffabil-
ity of God, with divine judgment and the fires of hell. Rever-
ent Hindus wish to die in Banaras and to be cremated in the
ghats on the banks of the Ganges in order to escape rebirth.
The yule log and the bonfires of midsummer solstice are but
two of the enduring pagan rituals that continue to unite fam-
ily and community in European-based cultures.

One of the few attempts to create a phenomenology of fire
was Gaston Bachelard's *The Psychoanalysis of Fire*, written in
1938. In seeking to answer the question "what is fire?" Bache-
lard studied both mythological and scientific explanations,
what he called the subjective and objective interpretations of
this element. Fire, he claimed, explains everything. Because it
is the ultra-living element, fire is both intimate and universal.
As it lives in our hearts, so it lives in the sky. It rises from the
depths of our being, and is expressed in love as well as hate. It
is good and evil, gentleness and torture.

The imagination, like fire, is an autochthonous realm.
The word *autochthonous* is derived from the Greek, *autos*,
"self" and *chthon*, "of the earth, land, or ground." The
imagination is as intrinsic to our nature as heat is to flame. It
inhabits us, as people inhabit the land. We need it, for only
the imagination allows us to contemplate the future without
forgetting the past.

Imagination works at the summit of the mind like a
flame. Who among us has not sat before a fire watching the
colors of the flame, watching the logs (or the paper or dung)
being consumed as we warm ourselves? Who among us has
not drifted into a state of reverie, reflecting about the past
and future as we watch the magic? The harnessing of fire was
clearly one of the most formative of human innovations.

Fire is *the* transformative element. It teaches us about the inexorability of change, in art as in life. M. C. Richards's musings about fire in *Centering* have been a touchstone for me. She wrote about the "innerness of the so-called outer world"—the ways in which we can read the physical elements as metaphors for inner processes. The kiln becomes the crucible of ur-fire, hellfire, the fire of suffering, the flame from which the phoenix rises. Fire purifies. If we watch the clay through its many stages, we may begin to understand the secrets of change, renewal, and transformation. Out of fire, the new is born and reborn again.

Adversity is like fire: It usually signals imminent change of some sort or the need for change. It is an integral part of life, and especially of the creative process.

What do you do now when faced with adversity? Do you fight it? Do you flee? What do you do when encountering obstacles, barriers, or blocks in what you thought was a straightforward process? How do you react when faced with a strenuous or formidable task, or when you come up against the limitations of your ability and knowledge? Or, what happens when your vision outstrips your ability or an accident irreversibly changes the direction of your work? These are all examples of the kinds of adversity you can expect to encounter in the creative process. The main question is, what to do?

Once, when I was attending an eight-day marble-carving symposium, I had an experience where all of these obstacles seemed to occur simultaneously. For nearly a year I had imagined carving a full-sized chair, on which I would write a few words. The form of the chair was simple, my plan precise. When I arrived at the marble site, I could not find a block of marble that was appropriate. But then I remembered

another idea that had fluttered around in consciousness during the past months: to make a standing stone. Previously, all of my work had been on horizontal stones, where I treated the marble as a two-dimensional surface on which to write. I had no real notion of what I was getting into, but the idea of a standing stone, approximately my height, was so compelling that I innocently selected a beautiful block of marble with veins that looked like lightning.

Then the trouble began. I was not trained as a sculptor, to think in three dimensions. I had never worked sculpturally in a subtractive medium such as stone. I had never faced the challenges of mass, volume, transitional planes, as well as surface, texture, and language for a large piece. None of my previous work in ceramics, drawing, installation, or performance prepared me for this challenge.

I can only say that I endured one breakdown after another. The stone had blemishes that I could not remove. I wanted to leave. I couldn't figure out what to do next. I wanted to avoid the site. I wanted to drop the project. I wanted to flail my arms, stamp my feet, cry in anguish. It all sounds silly in retrospect, but the experience was profound.

What did I do? I did not hit the stone or work on it aggressively, because stone bruises, just like people. I took breaks. I put my feet in the creek. I came to work after dark or at dawn, when I could be alone. Later, I asked for technical and conceptual help. I made drawings. I modified my ambitions. I got a massage. I returned to the stone again and again, when I felt calm and could look dispassionately at my progress. On the last day of the symposium, I wrote the words that I had planned for so long.

Through this process I learned a lot, about marble and about myself. I learned about scale and ambition. I learned

about the need to define a project carefully and not to set unrealistic expectations. I learned that I could address stone as a three-dimensional object in space, but that this was not my primary goal. I learned that my keenest pleasure comes from the one-pointed attention that is a requirement for writing in stone. More than anything else, I learned about the fire of adversity.

I could have fought the stone. I could have left the project. But I chose another path, staying with the frustration, taking another step forward when I knew that I could have turned back. The stone now stands in my garden, proclaiming "[THIS] PLACE" on its face. *This place*, being here, present, now, at this moment, to observe. Like the proverbial phoenix rising from the fire, I was transformed by the experience of working on this stone.

"Know thyself" is one of the oldest axioms, and it is especially pertinent as you encounter your own versions of my marble block. Learn to observe yourself, to name the experience, to stay with it, and to seek help in extending your vision so that you can embrace the fire without getting burned.

25

INNER WORK

Some artists prefer not to attend to their inner psychological life, but to live and create on the surface. I believe, however, that art is a means of actualization of the self, that the structure and practices of art help to free us from being driven by the unconscious and past experience.

For many of us at some point in life, art is therapeutic. As a healing discipline, art therapy is based on this fundamental insight. Art can be a means of traversing the minefields of your inner life, of healing wounds from the past, of opening to the present and future. It is, in fact, this remarkable transformative power that makes art such a powerful tool for consciousness and action.

How does the emotional life shape artistic aspiration? How do early experiences form our inner lives? I urge you to spend some time unraveling the psychological and physical threads that form the fabric of your life. Such time and energy will be well spent. As you learn about yourself, you will have greater control over who you are becoming, you will be less driven by unconscious forces, and this will have an enor-

mous impact on your creativity. Here I want to bring attention to the role of formative relationships in shaping your artistic identity. Ours is the era of story; we become who we are through creating narratives. Tell your inner psychological story. This is the inner work to which the title of the chapter alludes.

Let me give you an example of what I mean.

My mother died last night. Her small collection of personal possessions had already been dispersed; none of us knew where. This was my latest dream. Yet defying probability, my mother, Betsy, has continued to live, at times coherent, but more often confusing hallucination with reality. She is a ward of the state of Washington and lives in a nursing home in Seattle. The dream reminds me that she has been gone for a very long time.

I am the eldest of her four daughters. My mother was strict: She allowed no comic books, movie magazines, candy, or soda pop in the house, no bras until the seventh grade, no leg-shaving until age fourteen, no dating until sixteen. During my teen years, she attempted suicide, divorced my father, and a year later nearly died of a brain aneurysm. After she recuperated, she could not hold a job and was increasingly unable to care for us. Legal custody was given to my father and his new wife. Mom went to stay with her mother in California. Later she was sent back to Seattle because of the trouble she had caused there. She tried to work, but was in and out of hospitals with seizures and a tumor that resulted in brain surgery. State social workers put her in a nursing home in the late 1960s, where she has lived ever since.

Betsy had been an extremely bright young woman, valedictorian of her high school class. Both of her brothers went to college and entered professional life, but she did not. I

will never know exactly what thwarted her or what kept her from fulfilling the promise of her own teen years.

During the years of young adulthood, I struggled with fears that I would go mad, like my mother. How does one speak of madness? R. D. Laing understood schizophrenia, and one might say madness generally, as a sane reaction to insane conditions. To enter the world of a mad person is thus an occasion for better understanding the inhuman and inhumane conditions that determine social structures, including family relationships. But to enter the world of a mad person is also destructive, especially if that person is your mother.

Growing up in a family where being a mother meant that (a) you subordinated your aspirations to take care of others, (b) you were profoundly unhappy, and (c) you finally went crazy, I early made other plans for myself. Beginning at age sixteen, my boyfriend offered escape and solace. But I was a bright and ambitious teenager, and as I neared the end of high school, I had begun to drift away from him. I was headed to Austria and Russia to study Russian during the summer before college, and then to the university.

I got pregnant at seventeen, just prior to leaving for Europe, and found out during the week before college classes were to begin. Suffice it to say that subsequent events were traumatic for me, as I decided to relinquish my son for adoption. I was healthy and stayed in college, but I dropped out of Russian and took up art.

I was caught for years in a web of fear—fear of further loss, of living without love and without a mooring. These were the main themes of my early life. As a child and with my mother's example at hand, I had encountered that edge of madness where one risks slipping over into nothingness,

where suicide seems the way out. As James Hillman wrote in *Suicide and the Soul*, suicide expresses the urge for hasty transformation. Experiences in therapy, as well as yoga and art-making, have enabled me to explore that edge of the abyss without tumbling in.

"Twenty years in and out of therapy": That is my shorthand for the long and complicated process of personal healing and psychological exploration at the edges of madness. Rogerian humanism, Fritz Perls's inspired gestalt groups, Alexander Lowen's bioenergetics, Jungian-style dreamwork, a behavioral approach based on how to manage depression and fury, Progoff journal work, years of simply talking to crones. Later, yoga took the place of therapy. The body holds wounds. The body, wounded, carries pain for decades. I started serious yoga practice in 1975 at the Lindisfarne Association in New York. Even at the beginning I encountered pain in my chest and upper back that brought tears. Once, having done a range of postures, I related the pain in my sacrum to my mother's frequent spankings. In another workshop, I spent the entire weekend, or so it seems in memory, lying on the floor, crying. The body and its memories and afflictions showed me the way down and through into another state.

These experiences, described so briefly, profoundly shaped my aspirations and sense of vocation. My early decision not to follow my mother's path, *the mother's path*, created an imperative that I should find out who *I* was, what I wanted, and how I could be of service in the greater world. In an earlier era, women with these questions became nuns, or witches. I decided to become an artist. Earlier I noted that I do not believe only a few are born with special innate artistic talents. To be an artist means cultivating one's aesthetic

sensibilities, and for this, teachers can point the way. In fact, it would not be an exaggeration to say that I owe my life to teachers, including friends and mentors who affirmed me.

It took many years to come to terms with everything that had happened by the time I was twenty-one. Only in the late 1980s did I begin to feel at peace with who I was and am. It was around that time that I first learned about adoption searches and reunions. I attended a large gathering of birthmothers, adoptees, and adoptive parents. I joined a birthmother's group, where I learned from the experiences of four other birthmothers—about their decisions regarding relinquishment, about their pain, and about the technical details of initiating a search. And I conducted two searches, the first unsuccessful, the second successful six years later.

Fate and destiny work in inscrutable ways. I believe that our lives have shape and purpose, even if we cannot always easily discern them. One day I was feeling glum, mildly depressed, and overwhelmed by the stresses of work. I went down into the canyon where I lived, to sit by the stream. Nibbling chocolate, drinking a thermos of ginger tea, and writing in my journal, I thought about "my son," who had been an abstraction for nearly thirty years. I always reflected about him during the period around his birthday, and this year was no exception. That day, I didn't dwell on the question of whether we would ever be in touch with each other, but I just called him to mind. When I returned to the house, I felt better. Three days later, I received a telephone call from the Oregon Adoption Registry with his name and address. I was not surprised. For years I had wanted to be accountable to my son, to tell him that I acted in the best way I could at the time. A persistent myth about adoption is that when a

young woman relinquishes her baby, she moves on and forgets the past. Like most other birthmothers, I never forgot. Now, the years of our successful reunion are passing.

Once I recorded the following dream: *My mother pushes a baby carriage over the edge of a tall building, then mourns her baby's death. I feel the absurdity of her action. She is trying to force another older daughter to kill herself too. I am involved in a demonstration to see how far the daughter and I can approach death without actually dying. We finally decide to leave her and carry on our lives.*

As in this prescient dream, I have carried on. All women are not—and may not choose to be—mothers, but wrestling with both family and cultural values around motherhood has long been part of my path. My mother tried diligently to be a wife and mother to four girl-children, to raise us following strict moral guidelines, and to support our aspirations. It is not that she ultimately failed, for my sisters and I are all responsible citizens and creative individuals. In the process, however, she somehow destroyed herself. That, at least, is how it seems to me now.

Not long ago, I carved my mother's initials into a beautiful piece of Colorado yule marble. *M. E. C. H.* Grappling with a long-carried burden of sorrow about her fate, I decided to create a performance with the finished stone. "Requiem for a Wasted Life" was a thirty-day ritual performance.

Each day I walked with the stone, sometimes carrying it in a backpack, sometimes in my arms, held at my chest or belly. Down the dirt road to the park, around the wetland where the fall colors were changing, into the cemetery to face the rising sun, around the aspen grove, and back. Each day I

wrote in "Diary of a Requiem," a book I had bound, and in the studio I drew my daily route on a large sheet of black paper. On the twenty-ninth day, I carried the stone to the small historic cemetery, where I put it down and picked it up twenty-nine times. Back home, I wrapped it in linen, placed it in a stone hole I had prepared by the creek, sprinkled it with cornmeal, and piled rocks into the hole. I topped the rock pile with small stones, to mark an altar. After pouring water from the ice-covered creek over this altar, I sat. On the last day, I walked again. At the cemetery gate, I stopped to acknowledge the ritual process of literalizing my grief by carrying a twelve-pound stone each day for a month. Returning to the rock grave, I lit six candles and sage incense, placed a pink rose, and poured water. I said a Latin prayer of absolution. I forgive you. I release you. I release my sorrow. I release my sorrow. As my mother once had written to me, "said twice means I mean it!"

These events and inner experiences have shaped all aspects of my life as an artist and writer. This is why I advise you to tell your story. Free yourself from the past by dredging, struggling, and dealing with it. Examine the formative relationships in your life. And use what you learn to shape your creative work.

Sometimes, however, contemplative practice and psychological work are not enough. Perhaps your mind hungers for more, for an analytical and critical perspective on the divine, or ultimate reality, or the great mystery that surrounds you. You may be at the point where you are contemplating, or at least aware of, your mortality and impending death. You may feel religious yearning or great curiosity about an afterlife, or God, or the gods. For this, there is no language more appropriate than theology.

26

TOWARD A THEOLOGY OF ART

In your creative work, beware of "methodolatry," an idolatry of method that will cripple genuine creativity. Take risks. Do not abandon tradition completely, but experiment and play with images and symbols in order to surprise yourself. Consider theology as a resource.

Creativity is a dialogical process, like an authentic human conversation. You cannot script it, but it works best when you are attentive to serendipity and chance.

As a practicing artist, for many years I was propelled by the need to express "the sacred" through drawings, environmental installations, and performances. My artwork grew out of strong spiritual and ethical values, and I felt an urgent need to formulate a theoretical basis for this practice. As a writer, my concerns have ranged widely. But in both art and writing, I have consistently returned to one theme: to reaffirm the critical and revelatory potential of art within our commodity-driven culture that largely repudiates concern with religious and moral values in the arts.

The study of religion in general led me to theology, and what I learned has shaped my creative life ever since. I had turned to theology to better understand my own creative activity. When I came across Hans Blumenberg's idea that the self-conception of the artist and theoretical interpretations of the creative process were borrowed from theology, I knew that my theological study made sense. You may or may not feel that same impulse or compulsion, but if you are a serious artist, you may be interested in considering the possibilities and insights of a theology of art.

Although I had not studied it before, theology was never abstract or vague for me. Its meaning had everything to do with my teachers, including Gordon D. Kaufman, Margaret R. Miles, Richard Niebuhr, and Sharon Welch, to whom I am most grateful. With them I had opportunities to articulate my ideas about the sacred and the divine, about God. Curiously, I never wavered in my rejection of traditional Christian notions of God and Christ, but I used years of study to articulate my own theological perspective. In addition to my work with individual teachers, sustained reading of Mary Daly's prophetic work inspired both my interpretation of contemporary culture and my understanding of what theological discourse should do in the world.

The word *theology* means, literally, "language about God." Theology used to be known as the queen of the sciences, one of the primary forms of discourse that provided insight into the nature of the world and human experience. Now it is often viewed with suspicion, relegated to weekly religious sermons and religious tracts in the church, synagogue, mosque, or temple, or to conservative religious media. But theology—whether Christian, Jewish, Muslim, Hindu, or post-Christian—reinterprets the concepts of God, the world,

and the human. Imagination is determinative in this process. As Kaufman puts it, theology is an imaginative and constructive activity, an open and evolving discourse, rather than a set of revealed and tradition-bound doctrines. Imaginative theological construction is a form of creative authorship that helps us to articulate our place within the cosmos. As an artist, trained to think of my own work as imaginative and constructive, and knowing that my creative acts also helped me find my place in the world, I found such an interpretation of theology compelling.

During the years of my study, I began to develop a theory of creativity, which I called a theology of the arts. From one perspective, all of my work in the subsequent years has been an attempt to expand on this. A theology of the arts delineates the role of the arts in addressing the theological and ethical dimensions of culture, and it also sets forth the limits of what the arts can and cannot do for theological understanding. At the foundation, a theology of the arts is based on the idea that images are an especially efficacious means for expressing human understanding of the divine.

Art such as Russian icons and Tibetan *thangkas* are created explicitly for prayer and meditation. An icon *is* a form of theology. A *thangka is* a form of theology, even though there is no singular god in Tibetan Buddhism. Both visualize religious and theological insights. I also studied the broad religious aspirations of artists from different religious traditions and the way religious themes appear in modern and contemporary art.

I call this chapter *Toward* a Theology of Art, because what I have to say is more like a sketch than a finished painting or sculpture. I want to focus on five interrelated questions and issues pertinent to the topic.

First, the artist—for what can a theology of art actually be without the one who interprets and creates? The word *vocation* has a theological history, as I noted in the first chapter, and it is worthwhile to study the implications of that history when considering your own role as an artist. Artists serve and have performed many functions in cultures around the world and across time, from artisan and civil servant, to entertainer, illustrator, genius, hero, creator of consumer goods, healer, critic, prophet, and visionary. Over many years of study and writing about this, I have concluded that there is a great need today for artists who can cultivate their visionary imagination as well as prophetic and critical faculties.

Few writers or artists have articulated such a vehement and sustained critique of contemporary culture as Mary Daly has. Extremely sensitive to the imminent dangers threatening life on earth, Daly is an outspoken critic of the social and cultural patterns that have led to our current global crises. Her many books may be read as one continuously spiraling argument, articulating a prolonged plea for attention to the necrophilia, or love of death, that seems to pervade contemporary media culture. With Daly, I want to affirm *biophilia*, a vision of the interconnection of all living beings and the need to love all of life.

What kind of artist are you, or what kind of artist will you become? What do you feel called to do and to express? What is your vocation?

From this foundation, it is possible to address a second set of questions related to the revelatory, prophetic, and sacramental potential of the arts in general. Art is efficacious. It has the power to move us in profound ways, as well as to provoke fury and rage. The history of iconoclasm—the destruction of

images—provides ample evidence of this power. Images reveal insights about our historical moment, they criticize what is going on in the present, and they point the way toward the future. From Goya and Daumier to contemporary environmental artists, this prophetic potential of art has often been expressed. The arts can also help us to create ritual artifacts and participate in rituals and sacramental space and time.

Language is crucial to this process, and language, of course, is its own form of art in poetry and prose. But verbal language also has a place in the visual arts, from cubist and Russian constructivist experiments to the conceptual Art and Language group. Language itself can be revelatory, as Mary Daly's work demonstrates. I describe her work in some detail because it demonstrates the transformative power of language.

The title of Daly's book *Gyn/Ecology* exemplifies the way Daly creates with language. *Gyn* means "woman." Ecology is the science that deals with complex interrelationships of living organisms and their environments. She puns on the fact that most gynecologists in our culture are male, and that doctors, among others, can cause disease. The *Oxford English Dictionary* defines *gynecology* as "that department of medical science which treats the functions and diseases peculiar to women; also loosely, the science of womankind." So, writes Daly, "I am using the term . . . loosely, that is, freely, to describe the science, that is the process of know-ing, of 'loose' women who choose to be subjects and not mere objects of enquiry." Gyn/Ecology is, for her, the process of women dis-covering a web of loving relationships where everything is connected.

That Daly's language is simultaneously playful and didactic is most evident in her *Wickedary*. There, she defines

snool as "a cringing person," or "a tame, abject or mean-spirited person." Snools are the agents of the sadostate, that is, our society. Variously called bores, fakes, hacks, jerks, jocks, plug-uglies, rippers, sneaks, snookers, snot boys, and wantwits, these social types can "take over" individuals when they act in ways that help maintain patriarchy. Daly clearly understands how to use satire and humor as powerful literary devices. While her words may evoke laughter, behind their humor lies the conviction that unless changes happen now, our planet will become lifeless.

Daly also uses metaphors and symbols to develop her ideas. Metaphors are important because they evoke action and movement; they not only "Name change," but they also elicit change. Symbols are significant because, unlike signs, they participate in that to which they point. Her language can be brutal and lyrical, whimsical and acrimonious. Reading her work demands focused attention, yet yields both humorous and jolting insights. For the reader willing to travel with her, the journey is arduous. Yet her work demonstrates that language ultimately is a vehicle for the transformation of consciousness.

Is it possible to use language as an artistic element in your work? Consider how you might use verbal language alongside images and symbols. How might metaphors inform your artistic practice?

A third component of a theology of the arts concerns how the arts aid in understanding religious doctrines, as well as more secular ideas about the sacred. Here one looks straight into the core of theology. What God *is*, how we might conceptualize the divine and the sacred, is one of the first explicit tasks of theology. In contemporary theologies—liberation, feminist, ecological—ideas about God have

moved far from older conservative traditions, where "he" was visualized as an omnipotent father, lord, and master.

With the term *Be-ing*, for instance, Mary Daly emphasizes the importance of moving beyond anthropomorphic and reified concepts of God. Her claim in *Beyond God the Father* that, "when God is male, the male is god," became a touchstone for my own evolving criticism of Christian patriarchalism. By contrast, *Be-ing* is the "constantly Unfolding Verb of Verbs which is intransitive, having no object that limits its dynamism." This is Daly's way of signifying both ultimate and intimate reality, the idea that the divine and mundane always coexist.

I also am captivated by Gordon Kaufman's description of "serendipitous cosmic creativity" as it relates to the divine. "God," he suggests in *In Face of Mystery,* "is here understood as that ecological reality behind and in and working through all of life and history." With this idea he attempts to counter problems with traditional images of God as an all-powerful agent. Such images not only have been used to justify Western imperialism, enslavement of peoples, the subordination of women in social hierarchies, and the exploitation of the environment, but they are also based in a dualistic worldview where God is set over against the created world. "Creator" as the defining image of God implies a necessary rupture in reality between this creator and the created world. God is outside the world much like the potter, poet, or painter is outside of the created work. Kaufman argues that this view loses its intelligibility when we interpret the world as an interdependent evolutionary process and order. What, he asks, could be outside of the universe? We can affirm that there might be an inside and outside to the cosmos, but we cannot really conceptualize what an outside would be.

Understood within such a framework, the word *God* suggests the reality, power, or tendency working itself out in an evolutionary process of which we are a part.

The question of how the arts can visualize and provide an understanding of such ideas is open to the interpretation of individual artists. Art can be didactic, like some theology, or it can narrate its truths in a less overt way. My own installations are examples of attempting to create sacred space and time so that viewers might glimpse another reality. I urge you to explore the possibilities of giving form to such ideas in your own ways.

A fourth issue is broader, and concerns the role of both religious and secular institutions in supporting the arts. Unfortunately, the arts are often the first to be cut in times of limited budgets within public and private schools, colleges, and universities. I have little else to say about this at present, but there are scholars, religious people, and activists who are addressing the vital need to support the arts and the aspirations of artists in cultural institutions, from schools and religious institutions of all kinds, to museums and libraries.

Finally, a theology of art must address the theological and ethical dimensions of creativity. There are artists who would claim that their art evolves out of "pure" unmediated experience, or that it expresses no particular relationship with others, with history, nature, or the cultural worlds. I think this is nonsense.

Creative activity never occurs in a vacuum, but is always connected to one's past experience, social location, and to various strands of life in the present. It has both planned and serendipitous aspects. In fact, such serendipitous creativity is the source of all human cultures, including our languages, institutions, and all of the arts. We can become more humble,

human, and humane as we participate in such creative processes. Like conversation and authentic dialogue, creative work often results in surprising insights and unexpected directions.

My point is that none of this happens in a neutral space. Considered from a broad perspective, the products of artistic creativity may be considered as religious and moral acts precisely because of their consequences in the world. From this point of view, the creative process is also intrinsically religious and moral insofar as it involves actions for which we are responsible and accountable within a given community.

A theologically grounded artistic practice gives special attention to the question of idolatry. Idolatry means excessive or blind devotion to something. For instance, the devotion of contemporary American culture to consumption of goods is idolatrous. This is misplaced devotion. (As a friend's lapel button proclaims, "The best things in life are not things.") What demands our loyalty? How shall we evaluate all of the relative and conflicting claims for our attention, loyalty, and faith? To ask these questions is part of what it means to examine the theological and ethical dimensions of creativity.

Does theology lose its meaning and power when separated from a specific faith tradition? I do not think so, for theology is *the* form of discourse that has held the goal of describing and often prescribing ultimate values. In the end, theology may actually be one of the few forms of cultural discourse that can help us to gain orientation and to adjudicate among conflicting claims for our attention and loyalty.

In sum, a theology of the arts is based on the conviction that the artist has a personal calling, a vocation, to interpret the dilemmas we face, thereby giving voice to hopes and fears, experiences and dreams. In doing this, a theology of

the arts is also oriented to this world, to the present as it moves inexorably toward the future. And, it is active: It urges engagement and commitment to the world in order to bring about the political, social, and cultural transformation necessary for the embodiment of values such as love and justice.

I believe that the artist is connected to others and to the earth in relationships of profound risk and answerability. Relationships are contingent and relative; they are fragile and always involve risk. However, the quality of life, even the continuing possibility of life, is uncertain. A theology of the arts attempts to articulate these connections and interrelationships and to offer hope for the future.

At the risk of oversimplifying, I would suggest that art can be a special form of theology. Becoming conscious of how and why this is so has influenced my views both of the significance of visual art and of the artist's cultural function. If art *is* theology, then what do you want to say?

27

ART AND LIFE

Live your life as an art, for the place of art is in daily life.

Life is the major art for which we have to learn formal principles, develop technical skill, and hone conceptual acumen. Live with the memory of birth and the expectation of death. Create within that fragile and contingent context.

Without connection to life as it is lived, art is meaningless, or simply a commodity. Conversely, without art, life remains trivial, mundane.

I began *Art Lessons* with a chapter about the artist. I conclude the book's three main parts now with a short meditation about art itself. The book as a whole expresses a vision and a particular set of values about the relationship of art and life.

What should be the proper province of art? I believe that art is not an autonomous sphere, unconnected to life, where artists create, viewers view, and buyers buy. Rather, art—and here I mean all of the arts—exists in a profound dialogical relationship with life as you live it every day. As an artist, you engage in creative work within the time and space of daily life;

your artifacts and works of art live in this sphere too. They may, of course, have long lives in cultural history, as the *Nike* of Samothrace or the Russian *Spas nerukotvornyi* icon, or the Ryoanji Zen garden. But even such monuments of world art lived first in the daily lives of their creators and audience.

Obviously, the idea that art and life are connected is not new. A French literary critic coined the phrase "art for art's sake" in 1835. Some European scholars, critics, and artists believed in the sovereignty of the artist, and that the freedom of the artist to address solely aesthetic issues was essential. Such ideas found a particularly influential form in the twentieth-century criticism of Clement Greenberg, and many twentieth-century art movements would claim this lineage.

However, there have always been artists, critics, and philosophers who have vehemently argued that art must be connected with life. Robert Henri, Mikhail Bakhtin, and M. C. Richards are but three of those who have spoken and written passionately about this idea.

Robert Henri was a well-known painter in the early twentieth century, and one of the best known teachers of his time. He studied at the Pennsylvania Academy of the Fine Arts and in various ateliers in France. Later he taught in Philadelphia and New York; his students included well-known artists such as George Bellows and Edward Hopper. He was instrumental in helping to define a new, distinctly American, art for the twentieth century. His book, *The Art Spirit*, was published in 1923 and contains notes, articles, letters, and talks to students, all of which were compiled by one of his students, Margery Ryerson.

At the very beginning of *The Art Spirit*, Henri wrote, "Art when really understood is the province of every human being. It is simply a question of doing things, anything, well.

It is not an outside, extra thing." A person carried by this spirit of art is a seeker—searching, experimenting, inventing. Materials are less important than intention. Products are less important than the will to create.

About the same time that Henri was teaching in New York, Mikhail Bakhtin was just beginning to write philosophical essays in Russia. In his earliest essays, written between 1919 and 1926, Bakhtin used the Russian word *otvetstvennost'* to explain the relationship of art and life and of self and other. *Otvetstvennost'* may be translated as "responsibility" or "answerability." Art and life, he claimed in "Art and Answerability," must answer each other. "Without recognition of life, art would be mere artifice; without the energy of art, life would be impoverished." Art and life should respond to each other much as human beings answer each other's needs and inquiries in time and space. Answerability was Bakhtin's way of naming the fact that art, and hence the creative activity of the artist, is always related to life and lived experience.

Recognition of and commitment to answerability does not promise safety and comfort to an artist, or to any individual who takes seriously what it means. The way an artist creates, as well as the creative process more generally, expresses deep connection to life. Very often, life events and experiences determine what you do, although it may sometimes be easier to create if you do not attend to the situation of your life. Works of art live and influence people because they give shape and form to the consciousness of the self in relation to others. Through our creativity we are inextricably bound to one another and to our environment. Just as no one ever escapes the conditions of contingency and risk that pervade life, so the artist cannot avoid responsibility for her or his actions. Art answers to life and life answers to art,

as Bakhtin wrote. "Art and life are not one, but they must become united in me—in the unity of my answerability."

I have already written about M. C. Richards, in discussing teachers who were highly influential in my aesthetic education. M. C. is the person who taught me, in person, about the interconnectedness of art and life. "Life," she had written in *Centering in Pottery, Poetry, and the Person*, "is an art, and centering is a means. . . All the arts we practice are apprenticeship. The big art is our life. We must, as artists, perform the acts of life in alert relation to the materials present at any given instant." Following such guiding principles in my writing and artistic work over several decades, I have come to believe that the place of art is in everyday life.

All the arts we practice are indeed apprenticeships for the life we lead. Each of us lives in a unique chronotope, a particular nexus of time and place that is determined by personal circumstances, as well as social and political events, geography and topography, and climate. You are a situated being, and all dimensions of your life are influenced by your chronotope. Becoming aware of chronotopic themes and motifs can help to free you and create possibilities for change. If cruelty, distrust, and isolation fuel your life, then they will find form in your art as well. If attention, generosity, and compassion are the values that sustain your daily life, then these too will sustain your art. How you *do* art is how you will live.

Both art and life are nurtured by solitude, stillness, and silence. Therefore, seek silence. In the quiet of the studio and even amidst the noise of the street, we can kindle the imagination. I believe that we, as individuals and as a culture, desperately need the capacity to imagine the future. Art can help us reclaim the future, and the sense that there will be a future, in a time when so much is at risk. In *Homo Viator,*

French philosopher Gabriel Marcel wrote that hope is a memory of the future. Memory of the future? We must remember our relationships to life—to ourselves, to each other, and to the earth—if there is to be a future. Hope provides the impetus. Art is the means, the way, and the path.

ACKNOWLEDGMENTS

A book is a dialogue, a dialogue with people, places, and events of the past and present, a dialogue with ideas. I am particularly cognizant of how significant other people are to me. Like fragments of a conversation overheard, their voices linger in consciousness, instructing, coaxing, encouraging.

I therefore thank, first, all those who read drafts of chapters: Judy Anderson, Paulus Berensohn, Olga Broumas, David Campbell, Ross Coates, Julia Connor, Jane Dillenberger, Louise Dunlap, Susan Hawley, Gordon Kaufman, Karen Kitchel, George Kokis, Claire Wolf Krantz, Ann McCoy, Kate McKenna, David Morgan, Sonya Moseley, Bev Murrow, John Pierce, Rima Salys, Sara Schucter, Robert Spellman, and Ivy Walker. Birgitta Ingemanson read the text carefully, offered many suggestions, and helped with the transliteration of Russian words and names in the text. In general, I follow the Library of Congress style, but I have used accepted transliterations of proper names.

A leave from the University of Colorado during 2002 and 2003 provided time to finish the book, which was many years in preparation. Near the end of the project, Jessica Knapp provided research support, funded by an IMPART award from the University of Colorado.

A generous Contemplative Practice Fellowship from the Center for Contemplative Mind in Society helped to fund my year's leave and provided intellectual support for the book's focus on art as it relates to spiritual life and practice. This fellowship was

administered by the American Council of Learned Societies and made possible by support from the Nathan Cummings Foundation and the Fetzer Institute.

I thank Sarah Warner, senior editor at Westview Press, for her enthusiasm about publishing *Art Lessons* and her exceptional suggestions for revising the book. Anonymous readers sent useful feedback that I was able to incorporate during the final stages of revision.

Finally, I offer special thanks to my longtime companion David Thorndike and to my sisters Catherine Haynes, Marie Roby, and Ann Thomas, each of whom has taught me, from the beginning, about identity and difference.

NOTE: Chapter 8 contains material on Mikhail Bakhtin and Claude Monet, originally published as "Answers First, Questions Later: A Bakhtinian Interpretation of Monet's Mediterranean Paintings," in *Semiotic Inquiry*, 1999. Earlier versions of Chapters 14 through 18 concerning new technologies appeared in *The Art Journal* (October 1997), in the catalog accompanying *techno.seduction*, an exhibition at The Cooper Union in New York in early 1998, and in *Leonardo* (October 1998). Chapter 20 contains a few paragraphs from "The Work of Margaret R. Miles," published in the journal *ARTS, The Arts in Religious and Theological Studies* 13 (2001); and the section about M. C. Richards is related to three short pieces I published about her in *Opening Our Moral Eye* (Lindisfarne, 1996). Chapter 21 contains material published in "Gender Ambiguity and Religious Meaning in the Art of Remedios Varo," *Woman's Art Journal* (Spring/Summer 1995). An earlier version of Chapter 24, "Fire and Adversity," was published as "What Is Fire?" in *Artweek* (April 1998).

REFERENCES AND SUGGESTED READING

Alexander, Christopher, Sara Ishikawa, and Murray Silverstein, with Max Jacobson, Ingrid Fiksdahl-King, and Shlomo Angel. *A Pattern Language, Towns, Buildings, Construction.* New York: Oxford University Press, 1997.

Arendt, Hannah. *The Human Condition.* Chicago: University of Chicago Press, 1958.

Azara, Nancy. *Spirit Taking Form, Making a Spiritual Practice of Making Art.* York Beach, ME: Red Wheel/Weiser, 2002.

Bachelard, Gaston. *The Psychoanalysis of Fire.* Boston: Beacon Press, 1964.

Bacon, Francis. *Essays and New Atlantis.* New York: W. J. Black, 1942.

Bakhtin, Mikhail M. *Art and Answerability, Early Philosophical Essays by M. M. Bakhtin.* Edited by Michael Holquist and Vadim Liapunov. Translation and Notes by Vadim Liapunov. Supplement translated by Kenneth Brostrom. Austin: University of Texas Press, 1990.

_____. *The Dialogic Imagination, Four Essays.* Edited by Michael Holquist. Translated by Caryl Emerson and Michael Holquist. Austin: University of Texas Press, 1981.

_____. *Problems of Dostoevsky's Poetics.* Edited and translated by Caryl Emerson. Minneapolis: University of Minnesota Press, 1984.

_____. *Toward a Philosophy of the Act*. Translation and Notes by Vadim Liapunov. Edited by Vadim Liapunov and Michael Holquist. Austin: University of Texas Press, 1993.

Baldwin, James. *Nobody Knows My Name, More Notes of a Native Son*. New York: Dial Press, 1961.

Bambara, Toni Cade. *The Salt Eaters*. New York: Random House, 1980.

Bateson, Gregory. *Steps to an Ecology of Mind*. New York: Ballantine Books, 1972.

Belenky, Mary Field, Blythe McVicker Clinchy, Nancy Rule Goldberger, and Jill Mattuck Tarule. *Women's Ways of Knowing, The Development of Self, Voice and Mind*. New York: Basic Books, 1986.

Berdiaev, Nikolai. *The Destiny of Man*. Translated by Natalie Duddington. New York: Harper, 1960.

_____. *The Meaning of the Creative Act*. Translated by Donald Lowrie. New York: Collier, 1962.

Berensohn, Paulus. *Finding One's Way with Clay*. New York: Simon and Schuster, 1972.

Blumenberg, Hans. *The Legitimacy of the Modern Age*. Translated by Robert M. Wallace. Cambridge, MA: MIT Press, 1983.

Boyce, Mary. *A History of Zoroastrianism*. Leiden, The Netherlands: E. J. Brill, 1996.

Breton, André. *Communicating Vessels*. Translated by Mary Ann Caws and Geoffrey T. Harris. Lincoln: University of Nebraska Press, 1990.

Broude, Norma. *Impressionism, A Feminist Reading: The Gendering of Art, Science, and Nature in the Nineteenth Century*. New York: Rizzoli, 1991.

Broumas, Olga. *Soie Sauvage*. Port Townsend, WA: Copper Canyon Press, 1979.

Bulgakov, Sergei. *Filosofiia imeni* (Philosophy of the Name). Volume 2 of *Pervoobraz i obraz: sochineniia v dvukh tomakh*. Moskva: Iskusstvo, 1999.

Caws, Mary Ann, Rudolf E. Kuenzli, and Gwen Raaberg, eds. *Surrealism and Women*. Cambridge, MA: MIT Press, 1991.

Christ, Carol. *Diving Deep and Surfacing, Women Writers and Spiritual Quest*. Boston: Beacon Press, 1980.

Cixous, Hélène. *Coming to Writing and Other Essays*. Edited by Deborah Jenson. Translated by Sarah Cornell et al. Cambridge, MA: Harvard University Press, 1991.

Cohen, Hermann. *Aesthetik des reinen Gefühls*. Berlin: Bruno Cassirer, 1912.

Cole, Susan Quettel. *Theoi Megaloi: The Cult of the Great Gods at Samothrace*. Leiden, The Netherlands: E. J. Brill, 1984.

Daly, Mary. *Beyond God the Father, Toward a Philosophy of Women's Liberation*. Boston: Beacon Press, 1973.

———. *Gyn/Ecology, The Metaethics of Radical Feminism*. Boston: Beacon Press, 1978.

———. *Quintessence, Realizing the Archaic Future: A Radical Elemental Feminist Manifesto*. Boston: Beacon Press, 1998.

———. *Websters' First New Intergalactic Wickedary of the English Language*. Conjured in Cahoots with Jane Caputi. Boston: Beacon Press, 1987.

Daumal, René. *Mount Analogue, A Novel of Symbolically Authentic Non-Euclidean Adventures in Mountain Climbing*. Translation and introduction by Roger Shattuck. Baltimore: Penguin Books, 1974.

De Beauvoir, Simone. *The Second Sex*. New York: Knopf, 1953.

Descartes, René. *Discourse on Method and Meditations on First Philosophy*. Translated by Donald A. Cress. Indianapolis, IN: Hackett, 1993.

Dillard, Annie. *The Writing Life*. New York: Harper, 1989.

Dissanayake, Ellen. *Homo Aestheticus, Where Art Comes from and Why*. New York: Free Press, 1992.

Druckrey, Timothy, ed. *Iterations: The New Image*. Cambridge, MA: MIT Press, 1993.

Eliade, Mircea. *The Myth of the Eternal Return, or, Cosmos and History.* Translated by Willard Trask. Princeton: Princeton University Press, 1954.

_____. *Myths, Dreams, and Mysteries, The Encounter between Contemporary Faiths and Archaic Realities.* Translated by Philip Mairet. London: Harvill, 1960.

_____. *Rites and Symbols of Initiation, Mysteries of Birth and Rebirth.* Translated by Willard R. Trask. Dallas: Spring Publications, 1994.

_____. *The Sacred and the Profane, The Nature of Religion.* Translated by Willard R. Trask. New York: Harcourt, Brace, 1959.

Felski, Rita. *Beyond Feminist Aesthetics, Feminist Literature and Social Change.* Cambridge, MA: Harvard University Press, 1989.

Feuerbach, Ludwig. *The Essence of Christianity.* Translated by George Eliot. Introductory essay by Karl Barth. Foreword by H. Richard Niebuhr. New York: Harper, 1957.

Forster, E. M. "The Machine Stops." In *The Eternal Moment and Other Stories,* 13–85. New York: Harcourt, Brace, 1928.

Foucault, Michel. *Discipline and Punish, The Birth of the Prison.* Translated by Alan Sheridan. New York: Pantheon, 1977.

Friedan, Betty. *The Feminine Mystique.* New York: W. W. Norton, 1963.

Friedland, Roger, and Deirdre Boden, eds. *NowHere, Space, Time and Modernity.* Berkeley: University of California Press, 1994.

Geertz, Clifford. *The Interpretation of Cultures, Selected Essays.* New York: Basic Books, 1973.

_____. *Local Knowledge, Further Essays in Interpretive Anthropology.* New York: Basic Books, 1983.

Ghose, Aurobindo. *The Essential Aurobindo.* Edited by Robert A. McDermott. New York: Schocken, 1973.

Giroux, Henry. *Border Crossing, Cultural Workers and the Politics of Education.* New York: Routledge, 1992.

Gnoli, Gherardo. *Zoroaster's Time and Homeland, A Study on the Origins of Mazdeism and Related Problems.* Naples, Italy: Istituto Universitario Orientale, 1980.

Griffin, John Howard. *Black Like Me.* New York: New American Library, 1961.

Gsängert, Hans. *Mysterien Geschichte der Menschheit.* Freiburg, Germany: Verlag Die Kommenden, 1977.

Harding, Esther. *Woman's Mysteries, Ancient and Modern.* New York: Putnam, 1972.

Hassan, Ihab. "Prometheus as Performer, Towards a Posthumanist Culture?" *Georgia Review* 31 (Winter 1977): 830–50.

Hayles, N. Katherine. *How We Became Posthuman, Virtual Bodies in Cybernetics, Literature, and Informatics.* Chicago: University of Chicago Press, 1999.

Haynes, Deborah J. *Bakhtin and the Visual Arts.* New York: Cambridge University Press, 1995.

_____. *The Vocation of the Artist.* New York: Cambridge University Press, 1997.

Hegel, G. W. F. *Introductory Lectures on Aesthetics.* Translated by Bernard Bosanquat. Edited by Michael Inwood. New York: Putnam, 1993.

_____. *Lectures on the Philosophy of Religion: One Volume Edition, The Lectures of 1827.* Edited by P. C. Hodgson and J. M. Stewart. Translated by R. F. Brown. Berkeley: University of California Press, 1988.

_____. *Phenomenology of Spirit.* Translated by A. V. Miller. Oxford, England: Clarendon, 1979.

Heim, Michael. *The Metaphysics of Virtual Reality.* New York: Oxford University Press, 1993.

_____. *Virtual Realism.* New York: Oxford University Press, 1998.

Henri, Robert. *The Art Spirit.* Compiled by Margery Ryerson. New York: J. B. Lippincott, 1923.

Hillman, James. *Suicide and the Soul.* New York: Harper, 1964.

House, John. *Monet, Nature into Art*. New Haven: Yale University Press, 1986.

Hughes, Langston. *Selected Poems*. New York: Knopf, 1959.

Hurston, Zora Neale. *Their Eyes Were Watching God*. Philadelphia: J. B. Lippincott, 1937.

Huxley, Aldous. *Brave New World*. New York: Harper, 1950.

Huxley, Julian. *Religion without Revelation*. London: Watts, 1941.

Huyghe, Rene, trans. *Art Treasures of the Louvre*. New York: H. N. Abrams, 1951.

Itoh, Teiji. *The Japanese Garden, An Approach to Nature*. New Haven: Yale University Press, 1972.

Jackson, John Brinkerhoff. *A Sense of Time, A Sense of Place*. New Haven: Yale University Press, 1994.

_____. *Landscape in Sight, Looking at America*. Edited by Helen Lefkowitz Horowitz. New Haven: Yale University Press, 1997.

Jackson, Wes. *Becoming Native to This Place*. Washington, D.C.: Counterpoint, 1996.

James, William. *A Pluralistic Universe*. Cambridge, MA: Harvard University Press, 1977.

James, William. *Some Problems of Philosophy, A Beginning of an Introduction to Philosophy*. New York: Longmans, Green, and Co., 1911.

Kant, Immanuel. *Critique of Judgment*. Translated by Werner S. Pluhar. Indianapolis, IN: Hackett, 1987.

_____. *Critique of Practical Reason and Other Writings in Moral Philosophy*. Translated by L. W. Beck. Chicago: University of Chicago Press, 1949.

_____. *Critique of Pure Reason*. Translated by Norman Kemp Smith. New York: Humanities Press, 1950.

Kaplan, Janet. *Unexpected Journeys, The Art and Life of Remedios Varo*. New York: Abbeville, 1988.

Karr, Mary. *The Liar's Club*. Rockland, MA: Wheeler, 1995.

Kaufman, Gordon D. *An Essay on Theological Method.* Missoula, MT: Scholars Press, 1979.

_____. *In Face of Mystery, A Constructive Theology.* Cambridge, MA: Harvard University Press, 1993.

_____. *The Theological Imagination, Constructing the Concept of God.* Philadelphia: Westminster Press, 1981.

_____. *Theology in a Nuclear Age.* Philadelphia: Westminster Press, 1985.

Klee, Paul. *The Notebooks of Paul Klee.* Edited by Jürg Spiller. New York: Wittenborn, 1961.

Kornfield, Jack. *A Path with Heart, A Guide through the Perils and Promises of the Spiritual Life.* New York: Bantam, 1993.

Laing, R. D. *The Divided Self, A Study of Sanity and Madness.* London: Tavistock, 1960.

Lamott, Anne. *Bird by Bird, Some Instructions on Writing and Life.* New York: Doubleday, 1994.

Lehmann, Karl. *Samothrace, Guide to the Excavations and the Museum,* 5th ed. New York: Institute of Fine Arts, 1983.

Lehmann, Phyllis Williams, and Karl Lehmann. *Samothracian Reflections, Aspects of the Revival of the Antique.* Princeton: Princeton University Press, 1973.

Leopold, Aldo. *A Sand County Almanac, with Other Essays on Conservation from Round River.* Illustrated by Charles W. Schwartz. New York: Oxford University Press, 1966.

Lippard, Lucy R. *The Lure of the Local, Senses of Place in a Multicentered Society.* New York: The New Press, 1997.

Long, Richard. *Walking in Circles.* London: South Bank Centre, 1991.

Lovejoy, Margot. *Postmodern Currents, Art and Artists in the Age of Electronic Media.* Englewood Cliffs, NJ: Prentice Hall, 1992.

Lovelock, James. *Gaia, A New Look at Life on Earth.* New York: Oxford University Press, 1979.

Lyotard, Jean-François. *The Postmodern Condition, A Report on Knowledge.* Translated by Geoff Bennington and Brian Massumi. Minneapolis: University of Minneapolis Press, 1984.

Marcel, Gabriel. *Homo Viator, Introduction to a Metaphysic of Hope.* Translated by Emma Craufurd. Chicago: Henry Regnery Company, 1951.

Marks, Elaine, and Isabelle De Courtivron, eds. *New French Feminisms, An Anthology.* Amherst: The University of Massachusetts Press, 1980.

Marshall, Paule. *Praisesong for the Widow.* New York: Putnam, 1983.

Marx, Karl, and Friedrich Engels. *On Religion.* Introduction by Reinhold Niebuhr. New York: Schocken, 1964.

Mason, Mary G. "The Other Voice, Autobiographies of Women Writers." In James Olney, ed., *Autobiography, Essays Theoretical and Critical,* 207–35. Princeton: Princeton University Press, 1980.

Mason, Mary Grimley, and Carol Hurd Green, eds. *Journeys, Autobiographical Writings by Women.* Boston: G. K. Hall, 1979.

Miles, Margaret R. "Becoming Answerable for What We See." *Journal of the American Academy of Religion* 68 (3): 471–85.

_____. *Carnal Knowing, Female Nakedness and Religious Meaning in the Christian West.* Boston: Beacon Press, 1989.

_____. *Image as Insight, Visual Understanding in Western Christianity and Secular Culture.* Boston: Beacon Press, 1985.

_____. *Plotinus on Body and Beauty, Society, Philosophy and Religion in Third Century Rome.* Oxford, England: Blackwell, 1999.

_____. *Reading for Life, Beauty, Pluralism and Responsibility.* New York: Continuum, 1997.

_____. *Seeing and Believing, Religion and Values in the Movies*. Boston: Beacon Press, 1996.

Morrison, Toni. *Beloved*. New York: Knopf, 1987.

Morson, Gary Saul, and Caryl Emerson. *Mikhail Bakhtin, Creation of a Prosaics*. Stanford: Stanford University Press, 1990.

Neumann, Erich. *The Great Mother, An Analysis of the Archetype*, 2d. ed. Translated by Ralph Manheim. Princeton: Princeton University Press, 1972.

O'Faolain, Nuala. *Are You Somebody? The Accidental Memoir of a Dublin Woman*. New York: Henry Holt, 1998.

Ovalle, Ricardo, and Walter Gruen, eds. *Remedios Varo, Catalogue Raisonné*, 2d ed. Mexico City: Ediciones Era, 1998.

Pachter, Marc, ed. *Telling Lives, The Biographer's Art*. Washington, D.C.: New Republic Books and National Portrait Gallery, 1979.

Pissarro, Joachim. *Monet and the Mediterranean*. New York: Rizzoli, 1997.

Quinton, Anthony. "Philosophy." In Alan Bullock and Stephen Trombley, eds., *The Harper Dictionary of Modern Thought*, 646. New York: Harper, 1988.

Read, Herbert. "Toward a Duplex Civilization." In *Selected Writings, Poetry and Criticism*, 336–57. New York: Horizon Press, 1964.

Remedios Varo, 1908–1963. Exhibition catalogue. Mexico City: Museo de Arte Moderno, 1994.

Reynolds, Frank E., and Earle H. Waugh, eds. *Religious Encounters with Death, Insights from the History and Anthropology of Religions*. University Park: The Pennsylvania State University Press, 1977.

Rheingold, Howard. *The Virtual Community, Homesteading on the Electronic Frontier*. Reading, MA: Addison-Wesley, 1993.

Rich, Adrienne. *Compulsory Heterosexuality and Lesbian Existence*. London: Onlywomen Press, 1981.

Richards, Mary Caroline. *Centering in Pottery, Poetry, and the Person*. Middletown, CT: Wesleyan University Press, 1964.

_____. *The Crossing Point, Selected Talks and Writings*. Middletown, CT: Wesleyan University Press, 1973.

_____. *Opening Our Moral Eye, Essays, Talks and Poems Embracing Creativity and Community*. Edited by Deborah J. Haynes. Hudson, NY: Lindisfarne, 1996.

_____. *Toward Wholeness, Rudolf Steiner Education in America*. Middletown, CT: Wesleyan University Press, 1980.

Richmond, Yale. *From Nyet to Da, Understanding the Russians*. Yarmouth, ME: Intercultural Press, 1992.

Roszak, Theodore. *The Cult of Information, A Neo-Luddite Treatise on High-Tech, Artificial Intelligence, and the True Art of Thinking*, 2d ed. Berkeley: University of California Press, 1994.

Saiving, Valerie. "The Human Situation, A Feminine View." In Carol Christ and Judith Plaskow, eds., *Womanspirit Rising, A Feminist Reader in Religion*, 25–42. San Francisco: Harper, 1979.

Sale, Kirkpatrick. *Rebels Against the Future, The Luddites and Their War on the Industrial Revolution: Lessons for the Machine Age*. Reading, MA: Addison-Wesley, 1995.

Shulman, Alix Kates. *A Good Enough Daughter, A Memoir*. New York: Schocken, 1999.

Singerman, Howard. *Art Subjects, Making Artists in the American University*. Berkeley: University of California Press, 1999.

Solovyov, Vladimir. *The Meaning of Love*. Edited with a revised translation by Thomas R. Beyer, Jr. West Stockbridge, MA: Lindisfarne, 1985.

Spate, Virginia. *Claude Monet, Life and Work*. New York: Rizzoli, 1992.

Spirn, Anne Whiston. *The Language of Landscape*. New Haven: Yale University Press, 1998.

Stanley, Liz. *The Auto/biographical I, The Theory and Practice of Feminist Auto/biography*. New York: Manchester University Press, 1992.

Stanton, Domna C., ed. *The Female Autograph, Theory and Practice of Autobiography from the Tenth to the Twentieth Century*. Chicago: University of Chicago Press, 1987.

Steiner, Rudolf. *How to Know Higher Worlds, A Modern Path of Initiation*. Translated by Christopher Bamford. Hudson, NY: Anthroposophic Press, 1994.

Stone, Merlin. *When God Was a Woman*. New York: Dial Press, 1976.

Stuckey, Charles, ed. *Monet, A Retrospective*. New York: Hugh Lauter Lenin, 1985.

Taylor, Mark C., and Esa Saarinen. *Imagologies, Media Philosophy*. New York: Routledge, 1994.

Teilhard de Chardin, Pierre. *Pierre Teilhard de Chardin, Writings*. Selected with an introduction by Ursula King. Maryknoll, NY: Orbis Books, 1999.

Thompson, William Irwin. *At the Edge of History*. New York: Harper, 1971.

_____. *Passages about Earth, An Exploration of the New Planetary Culture*. New York: Harper, 1974.

Thoreau, Henry David. *The Natural History Essays*. Salt Lake City: Peregrine Smith, 1980.

Tolstaya, Tatiana. "Notes from Underground." *The New York Review of Books* 37 (May 31, 1990): 4.

Tolstoi, Leo N. *Anna Karenina*. Edited and introduced by Leonard J. Kent and Nina Berberova. New York: Modern Library, 1965.

_____. *War and Peace*. Translated by Louise and Aylmer Maude. New York: Simon and Schuster, 1942.

_____. *What Is Art?* Translated by Aylmer Maude. Indianapolis, IN: Hackett, 1960.

Turkle, Sherry. *Life on the Screen, Identity in the Age of the Internet*. New York: Simon and Schuster, 1995.

Voznesensky, Andrei. *Selected Poems*. Translated by Herbert Marshall. New York: Hill and Wang, 1966.

Waldron, Jan L. *Giving Away Simone*. New York: Times Books, 1995.

Walker, Alice. *The Color Purple*. New York: Pocket, 1982.

Walker, Margaret. *Jubilee*. Boston: Houghton Mifflin, 1966.

Williams, Raymond. *Keywords, A Vocabulary of Culture and Society*, revised ed. New York: Oxford University Press, 1983.

Wilson, Barbara. *Blue Windows, A Christian Science Childhood*. New York: Picador, 1997.

Wright, Richard. *Native Son*. New York: Harper & Brothers, 1940.

X, Malcolm. *The Autobiography of Malcolm X*. With the assistance of Alex Haley. Introduction by M. S. Handler. Epilogue by Alex Haley. New York: Grove Press, 1966.

Yates, Wilson. *The Arts in Theological Education, New Possibilities for Integration*. Atlanta: Scholars Press, 1987.

Yevtushenko, Yevgeny. *The Collected Poems, 1952–1990*. Edited by Albert C. Todd with the author and James Ryan. New York: Henry Holt, 1991.

INDEX